welcome
BOOKS
A Division of
Rizzoli New York

The GREAT SMOKY MOUNTAINS

The
GREAT SMOKY MOUNTAINS

Blue Ridge Parkway and Shenandoah National Park

Carl Heilman II

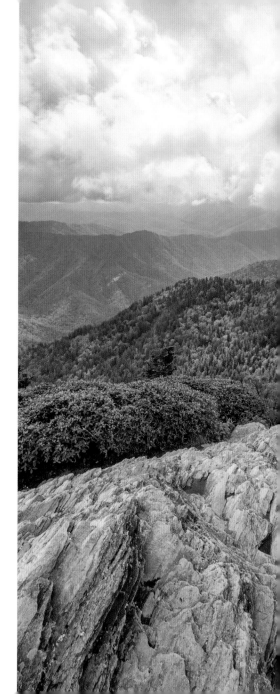

(Pages 2–3) The rosy glow of dawn light colors the Blue Ridge Mountains.

▶ *Hikers enjoy the view over the Smokies from Cliff Top on Mount LeConte.*

Welcome Books®
A Division of Rizzoli International Publications, Inc.
300 Park Avenue South
New York, NY 10010
www.rizzoliusa.com

Project Editor: Candice Fehrman
Book Design: Lori S. Malkin

Since its inception in 1953, the Great Smoky Mountains Association (GSMA)
has supported the preservation of Great Smoky Mountains National Park
by promoting greater public understanding and appreciation through
education, interpretation, and research. A nonprofit organization, GSMA has
provided more than $36 million to the park since its formation. Its funds are
generated through retail sales to park visitors and its membership program.
Anyone interested in deepening their relationship with Great Smoky
Mountains National Park is invited to become a GSMA member. For more
information, please visit www.smokiesinformation.org.

Photos on pages 160–171 are used with permission from
The Biltmore Company, Asheville, North Carolina.

2018 2019 2020 2021 / 10 9 8 7 6 5 4 3 2 1

Printed in China

ISBN-13: 978-1-59962-144-9

Library of Congress Catalog Control Number: 2017954551

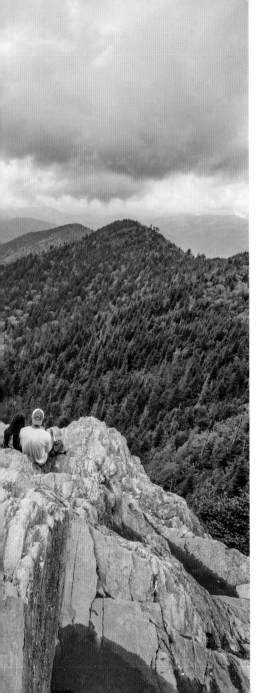

Contents

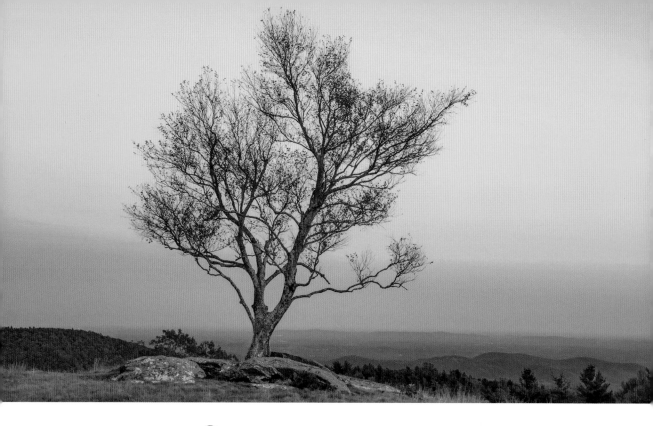

Preface

by Laurel Rematore, *Chief Executive Officer, Great Smoky Mountains Association*

COMING TO THE GREAT SMOKY MOUNTAINS feels like coming home. There is a special irony for me in this frequently used description. You see, I am a California native; my first visit to the Smokies was only four years ago. As a teen, I imprinted on one of the iconic western national parks situated in a much younger, taller mountain range, and that place will always be *my* park. I am lucky that my imprinting also became the foundation upon which my life

and career were built: stewardship of public lands. I hope I never lose the craving to visit parks, monuments, and other publicly protected open spaces. These places preserve this country's history: its staggering beauty, remarkable ecosystems, and the human experiences intertwined throughout. The continued protection of these places and the opportunity to learn their stories are a reflection of this nation's values.

The idea of "home" may conjure feelings of warmth and protection, shelter from the elements, a gathering place, a location we return to in hopes of finding the familiar. The stories of Great Smoky Mountains National Park are all of home: the homesteading families whose land became the park, the Native Americans who were here before, even the enormous diversity of plants and animals that still make their homes in the park today. These stories tell of tremendous hardship too. One needs only to read the epitaphs in a church cemetery or experience a windstorm here to appreciate that life in the Smokies includes risk and tragedy.

Just as we take care of our physical homes, we all have a responsibility to care for public lands. It begins with asking questions. As you take in the undulating landscape from a roadside overlook, perhaps you will wonder how earlier residents got around without the convenience of asphalt roads. When you hike to Andrews Bald to admire the flame azalea and Catawba rhododendron, perhaps you will venture further down the Forney Ridge Trail to see what lies beyond the bald. Great Smoky Mountains National Park preserves many historic buildings that are remarkably easy to access today, and yet others—like those found in the Hazel Creek watershed—are viewed only by intrepid hikers and horsemen who venture well beyond the shores of Fontana Lake. Hidden in those landscapes are the varied histories of Native Americans, pioneer families, timber barons, miners, and so much more— all awaiting your discovery. The Great Smoky Mountains Association is dedicated to answering your questions and telling these stories, and there is no shortage of work to be done.

Welcome to my remarkable, beautiful Great Smoky Mountains home. Perhaps you and I will soon meet on a trail here, for I have much still to learn from this place.

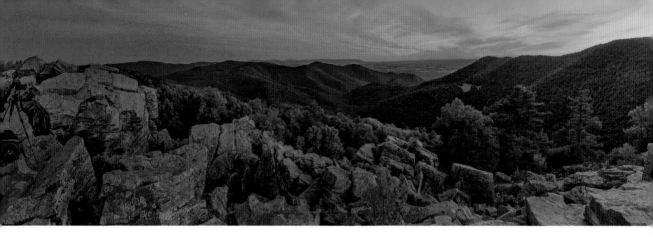

Introduction

THE 500-MILLION-YEAR-OLD APPALACHIAN MOUNTAIN RANGE stretches along the eastern North American continent from northern Georgia to Maine, Quebec, Nova Scotia, and Newfoundland. The Appalachians include many regional mountain ranges, such as the rugged Chic-Choc Mountains in Quebec, the gentle Poconos in Pennsylvania, and the dramatic White Mountains in New Hampshire. The White Mountains have many peaks that tower well above timberline and include Mount Washington, which at 6,289 feet is the highest mountain in the northeastern United States, but there is another range with even higher mountains to the south.

The spectacular Blue Ridge mountain range stretches some 615 miles along the southeastern border of the Appalachians from Carlisle, Pennsylvania, through Maryland, Virginia, North Carolina, Tennessee, and South Carolina to Mount Oglethorpe, Georgia. This rather long, narrow mountain range varies from only five miles wide to around 65 miles wide closer to the southern end. The best-known and most-traveled regions of the Blue Ridge include the Great Smoky Mountains, the Blue Ridge Parkway, and Shenandoah National Park and Skyline Drive.

This close-to-360-degree view shows sunset color over the mountains from Blackrock Summit in the southern Shenandoah National Park.

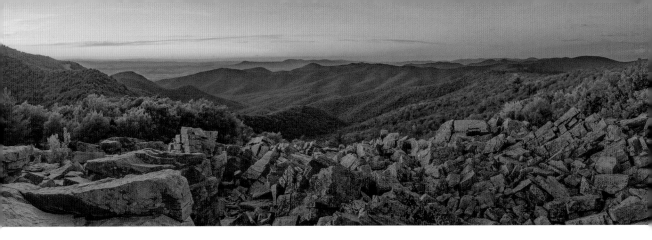

The Blue Ridge Mountains have a rather unique geology with an overthrust of metamorphic rock that covers a base of sedimentary rock, so there is a lot of weathered granite in addition to jagged, layered outcroppings. The range forms a continental divide between water flowing to the Atlantic on the east and north sides of the range, and water flowing to the Gulf of Mexico on the west side. The Appalachian Trail traverses the length of the Blue Ridge as it winds up and down over a number of the 125 peaks over 5,000 feet in height. In North Carolina and Tennessee, 39 of these peaks rise higher than 6,000 feet. At 6,684 feet, Mount Mitchell is the highest mountain in the eastern United States.

I first enjoyed visiting the Blue Ridge region during my college years in the mid-1970s, traveling along the Blue Ridge Parkway and Skyline Drive on my way home from West Virginia. It was a number of years before I came back and did some camping and hiking with my son, and then explored the area with my wife not long after that. I thoroughly enjoyed learning more about the region on the five recent trips I took along the length of the Blue Ridge from Shenandoah National Park to the Smokies as I photographed for this book. It is my hope that these photographs inspire each reader to further explore and revisit the spectacular drama and amazing diversity found in the beautiful Blue Ridge Mountains.

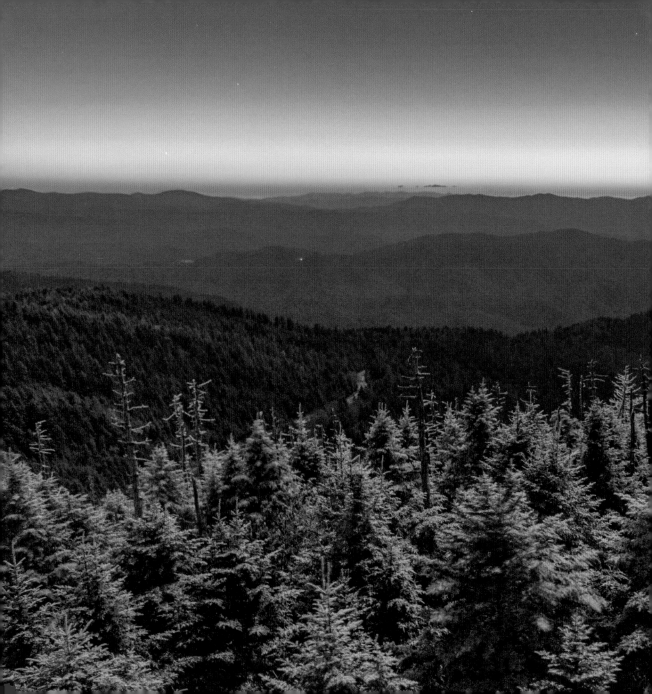

Great Smoky Mountains

WE ARE DRAWN TO THE GREAT SMOKY MOUNTAINS for the scenery, but we stay to enjoy the wildlife, valleys, mountaintops, streams and waterfalls, flora and fauna, history, hikes and magnificent views, and the magical feeling that comes from being there. And, as with every national park I've visited, there are many reasons the landscape was protected as a park for everyone to appreciate and enjoy.

The Smokies—which are also a UNESCO World Heritage Site—are renowned for their unspoiled temperate climate biodiversity, with more species of amphibians and wildflower varieties than any other national park. The 5,800-foot elevation change from Abrams Creek to the 6,643-foot summit of Clingmans Dome transports a person from the hard and soft-wood forests of the Deep South to a boreal spruce and fir forest typically found a thousand miles farther north.

Some of the Smokies' natural wonder is untouched, with huge virgin trees mingled with gnarled rhododendron throughout the park, plus the largest block of virgin red spruce in the world. There is also a history of people here that has been re-created in the Oconaluftee Farm Museum and nearby Mingus Mill, as well as in other valleys in the park. Cades Cove, the most-visited section of the park, is as much about the history of the people as it is about the beauty of the mountains rising all around the maintained fields, with wildlife wandering among the pastured horses and scattered woods in the valley.

(Pages 10–11) The rosy glow of dawn arrives over the Great Smoky Mountains from the tower on Clingmans Dome.

▶ *Cades Cove is seen from a breezy Gregory Bald, one of a few remaining open balds in the Smokies where residents used to graze their livestock.*

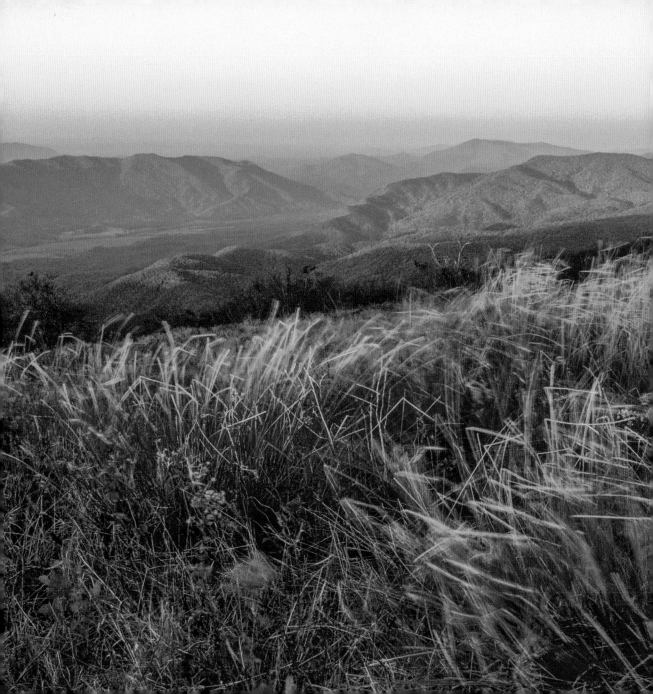

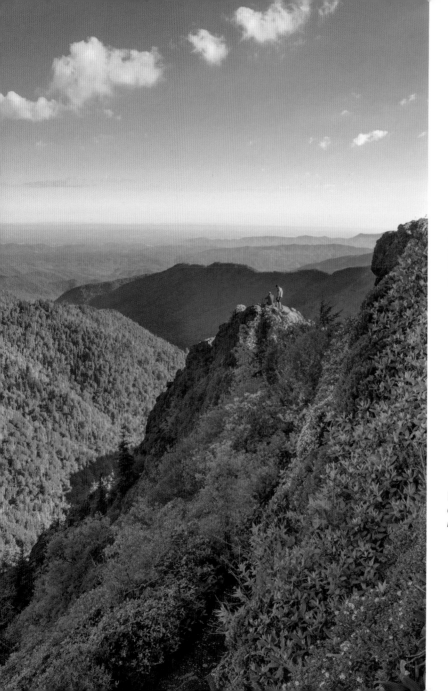

◀ A couple of hikers enjoy the spectacular view from Charlies Bunion, an outlook along the Appalachian Trail.

▶ The view from the craggy Charlies Bunion is one of the most dramatic in the park.

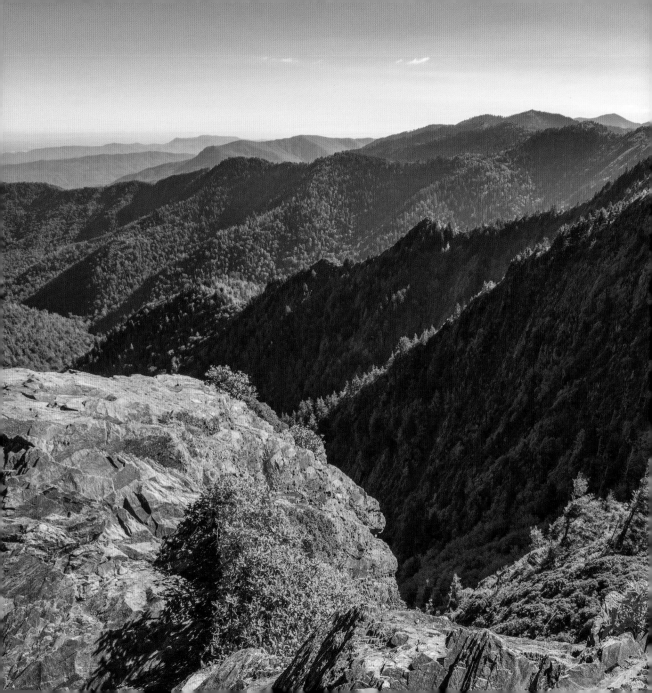

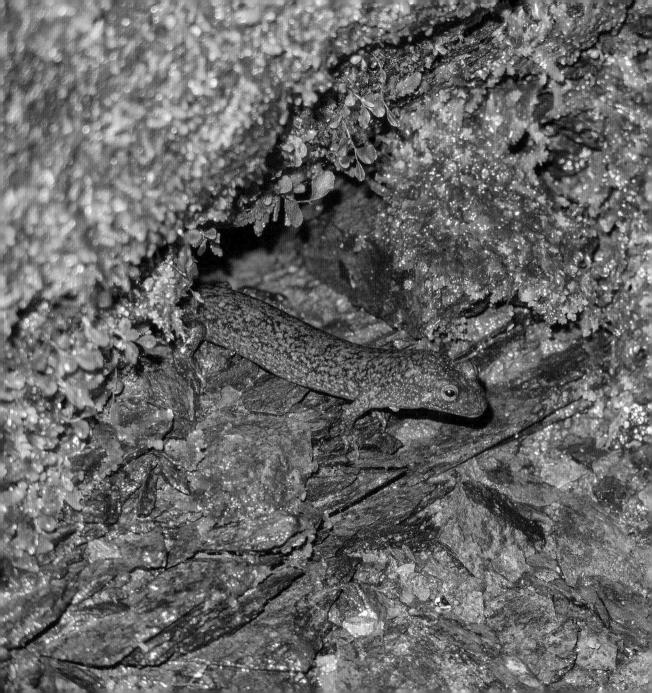

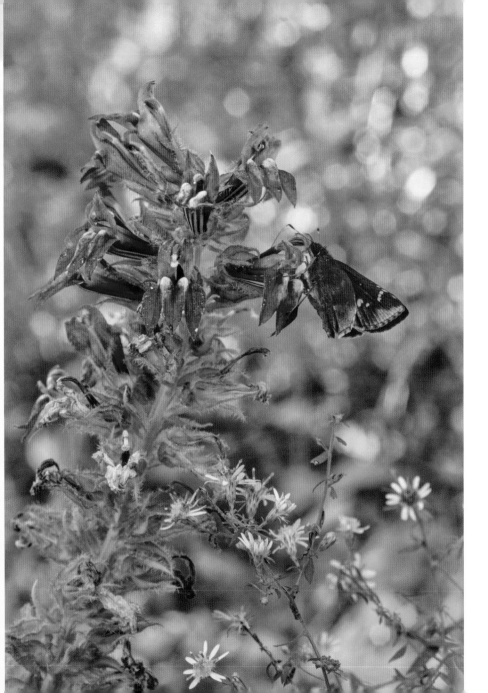

◀◀ *A blackbelly salamander peeks out of his tiny cave near a Great Smoky Mountains waterfall.*

◀ *A duskywing butterfly lands on blue cardinal flowers along a trail in the Deep Creek area.*

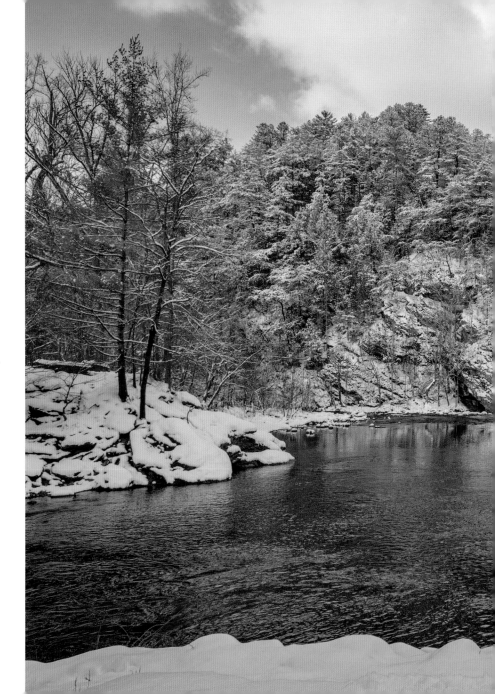

A popular area for visitors and locals alike in the summer, this section of the Little River has a different allure after a fresh snowfall.

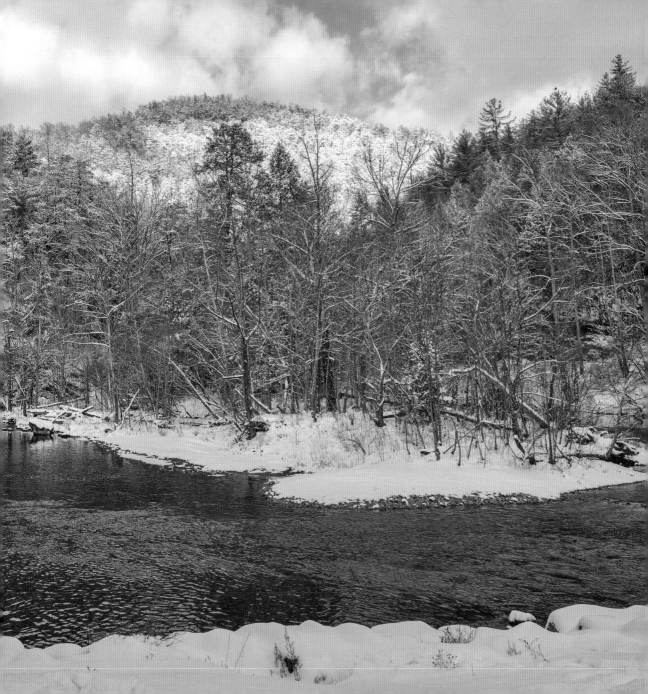

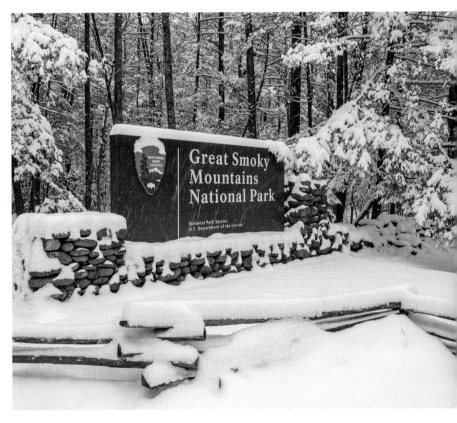

▲ The snow-covered sign by the Gatlinburg, Tennessee, entrance is a good reminder that a few inches of snow will typically close roads in the park.

◀ The Little Greenbrier Schoolhouse, built in 1881, doubled as a Primitive Baptist Church until 1925.

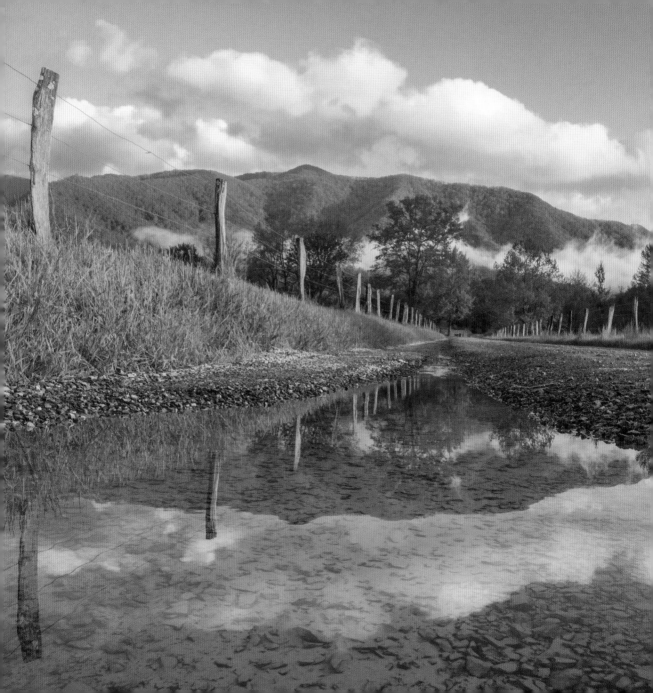

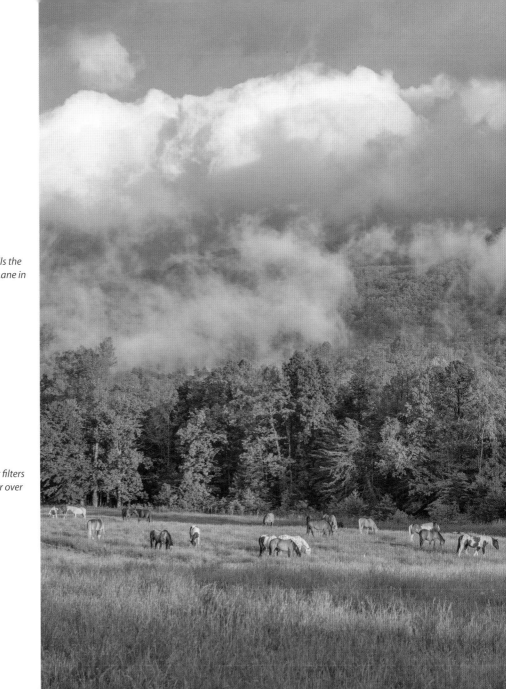

Evening light fills the sky above Sparks Lane in Cades Cove.

Afternoon light filters in as the skies clear over Cades Cove fields.

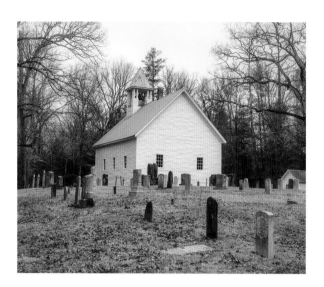

▲ *The Cades Cove Primitive Baptist Church was built in 1887 and used for services for about 75 years.*

▶ *A large whitetail buck looks about while grazing as a winter storm moves in.*

(Pages 26–27) Cades Cove fields are visible from the John and Lucretia Oliver Cabin, which was built in the 1820s.

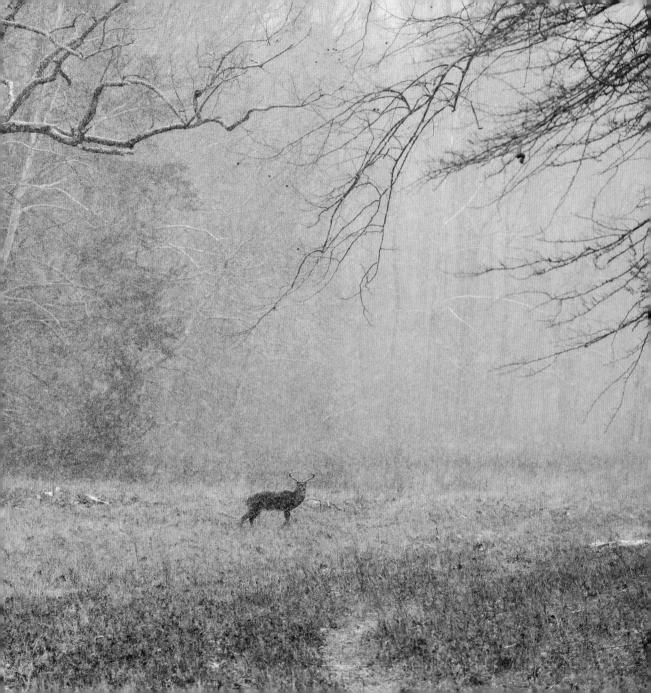

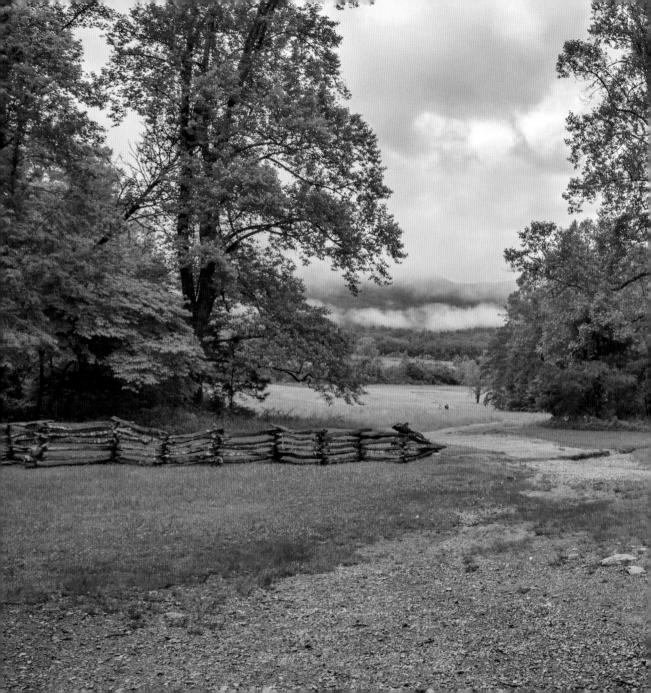

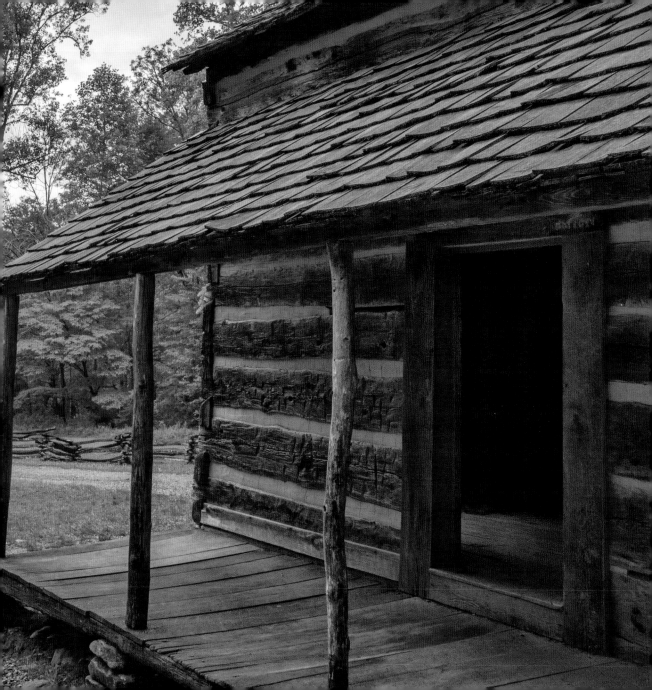

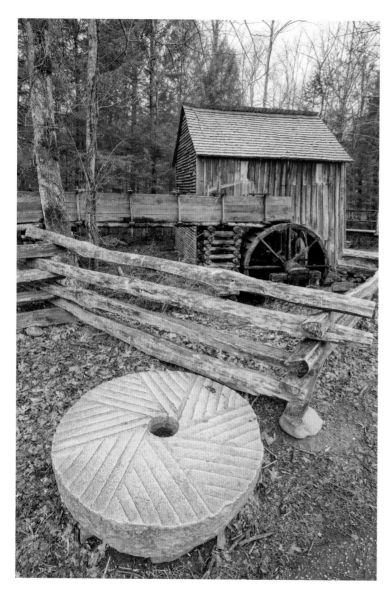

◀ The historic John Cable Grist Mill by the Cades Cove Visitor Center was built in the 1870s.

▶ The Tipton House, built after the Civil War, is seen through the cantilever barn.

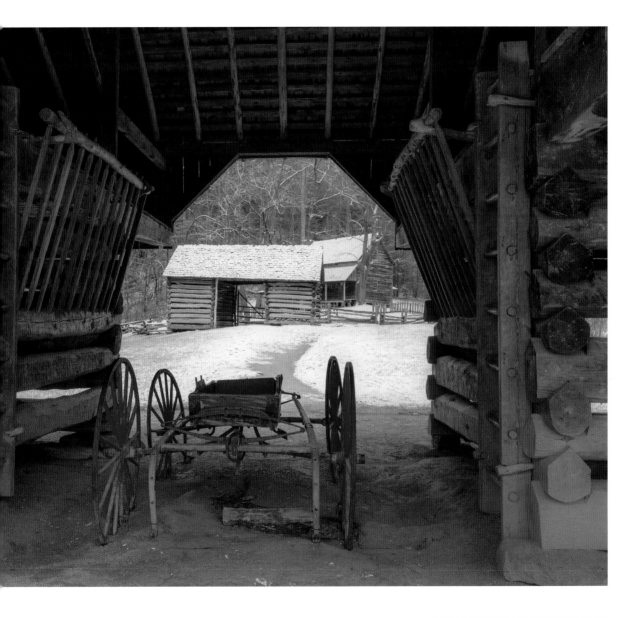

GREAT SMOKY MOUNTAINS ■ 29

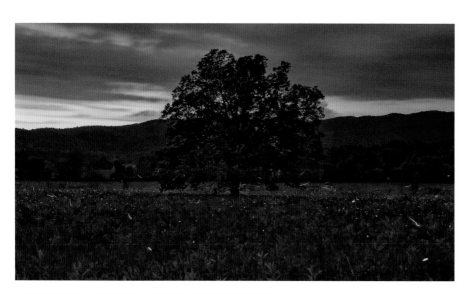

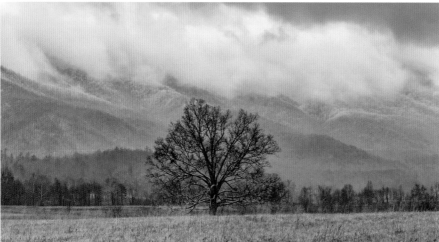

In June, the fields are often filled with fireflies once the sun goes down (top). A winter storm moves in from near the Hyatt Road intersection with the Loop Road (above). The southern part of the Loop Road is a great place to view Cades Cove sunsets (right).

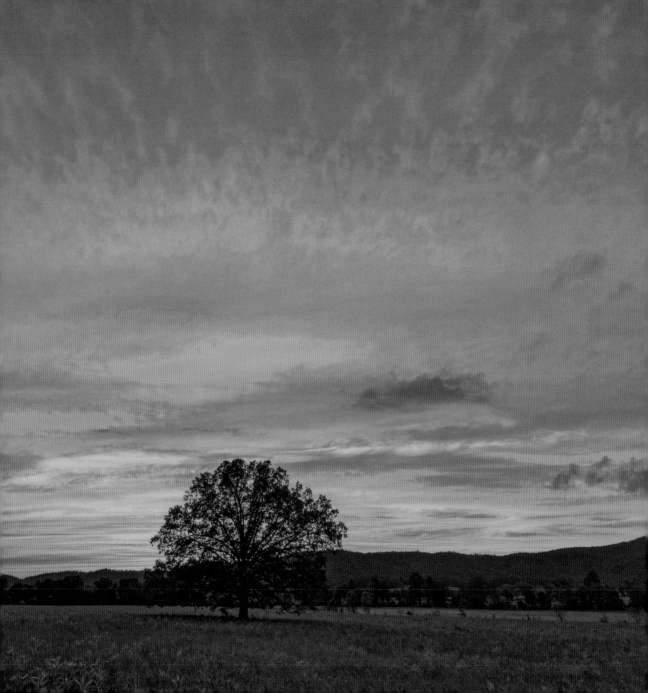

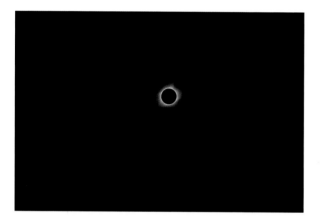

▲ Cades Cove was a spectacular location to view the Great American Eclipse on August 21, 2017, as the valley was covered for nearly two minutes in totality.

▶ The last edge of light from the sun before totality forms what is known as the "diamond ring." Seven seconds later, the next photo shows full totality.

▶▶ During the height of totality, Venus and a few other stars and planets were visible overhead, shining through the deep blue-black shadow of the moon, while the horizon in all directions glowed gently with the colors of sunset.

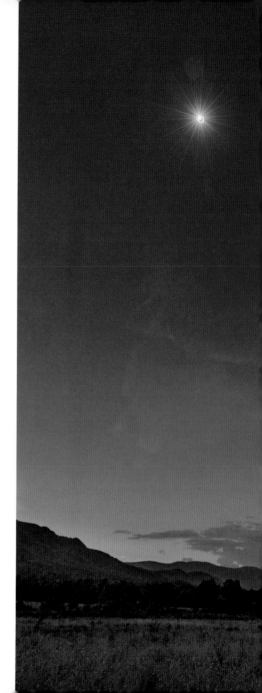

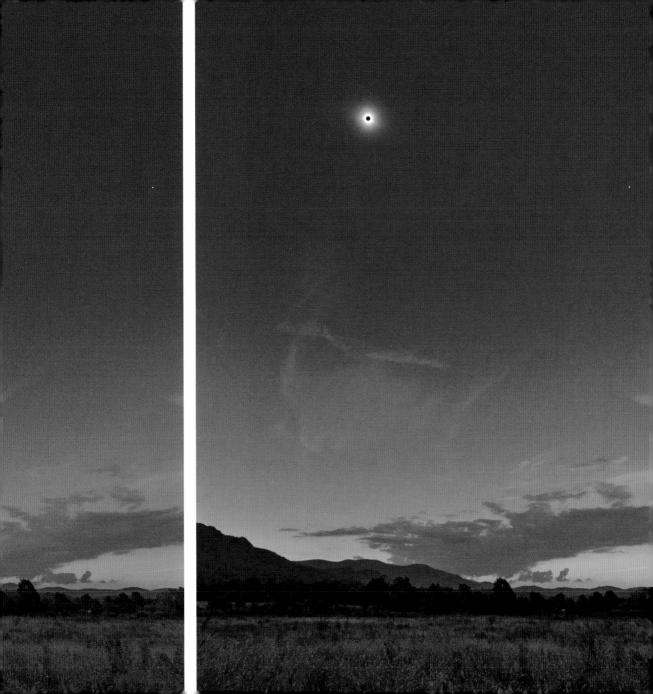

*Sunset colors
the Cades Cove
landscape along
Sparks Lane.*

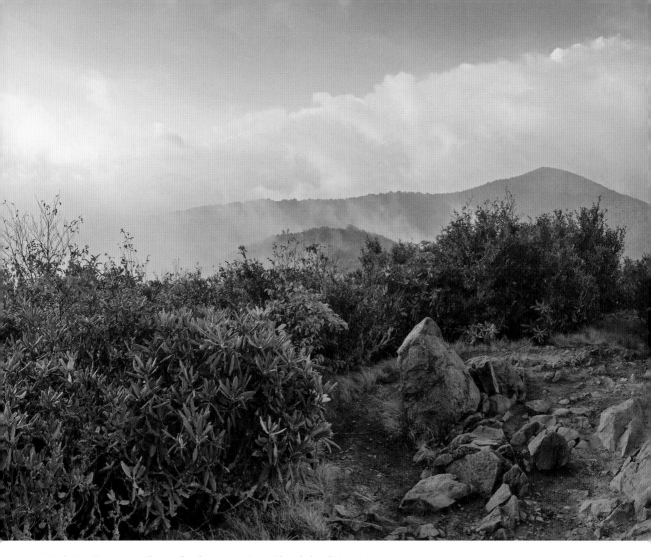

*Rocky Top, Tennessee—this small rocky outcropping on Thunderhead Mountain
inspired the lyrics for the bluegrass song that became an anthem for Tennesseans.*

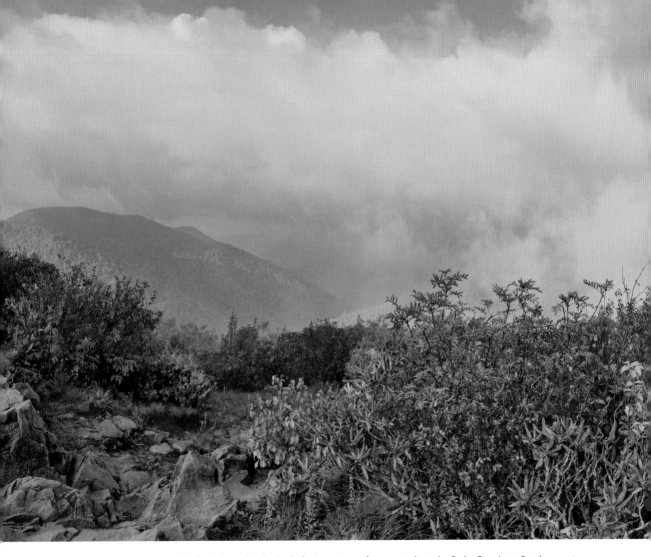

(Pages 38–39) *CLOCKWISE FROM LEFT: A pileated woodpecker looks for insects on a fence post along the Cades Cove Loop Road; a coyote on a search for an evening meal heads across Sparks Lane; this black bear on Gregory Bald will come searching for a camper's dinner as soon as he hears a stove start up; a wild turkey struts through a Cades Cove field; a black-chinned red salamander crawls along the trail to Laurel Falls.*

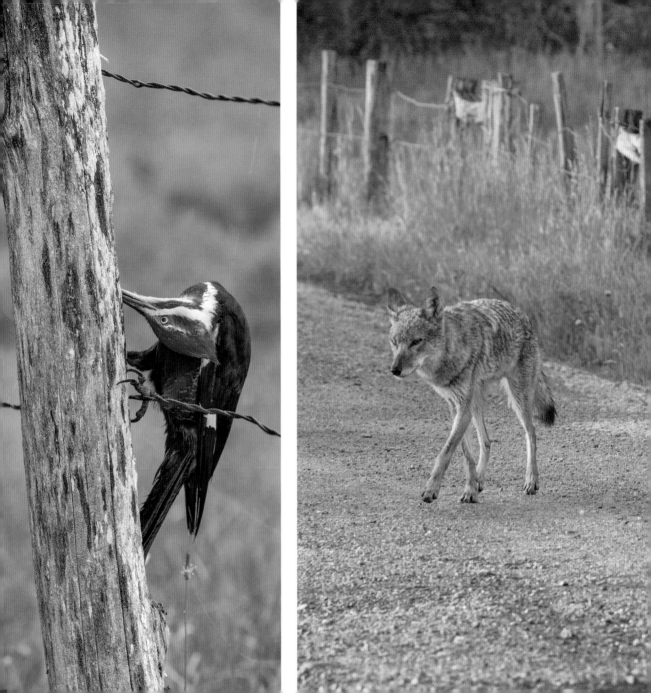

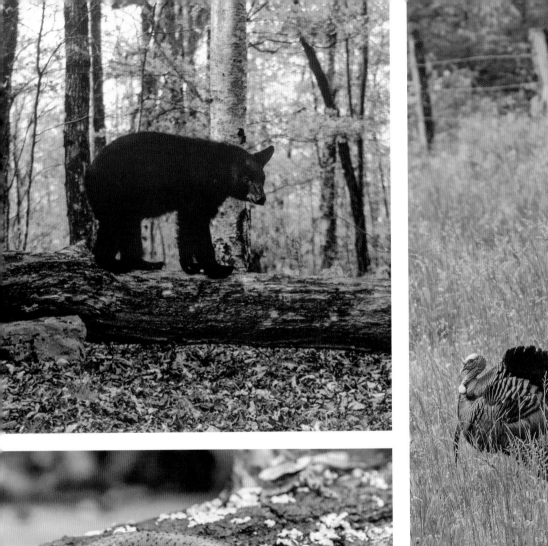
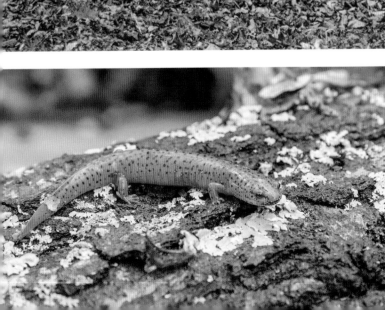
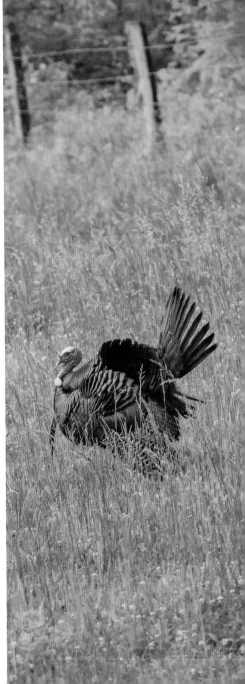

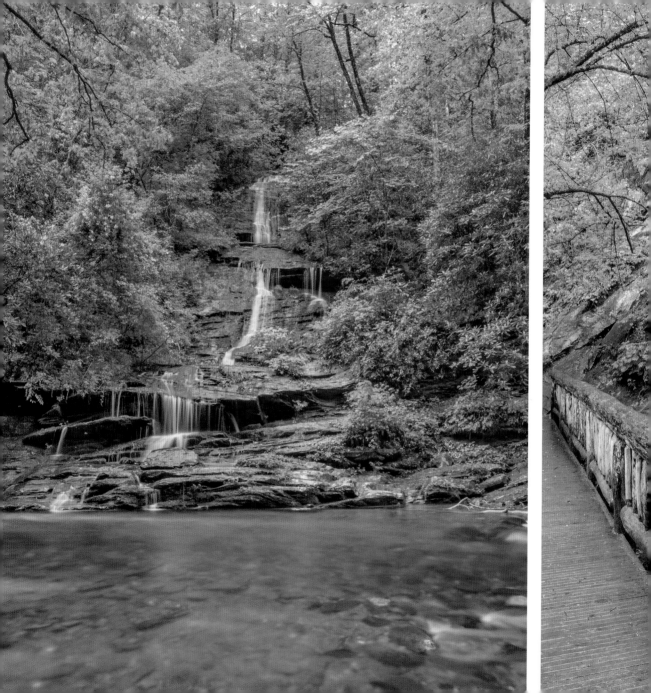

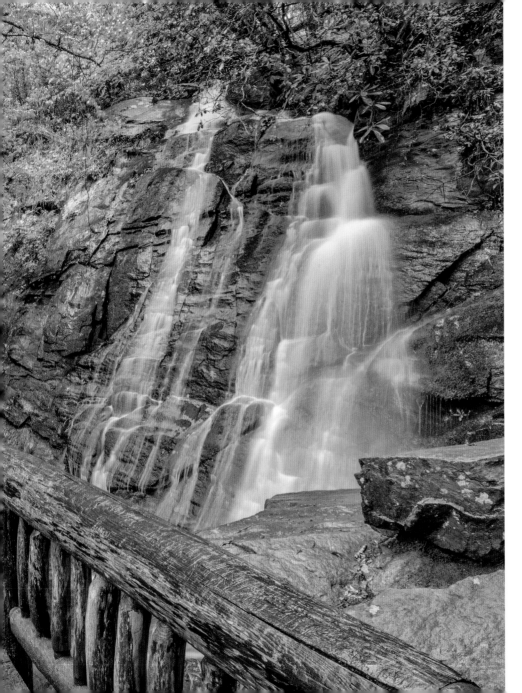

◄◄ *The 60-foot-high Tom Branch Falls is easily accessible from the Deep Creek trailhead near Bryson City, North Carolina.*

◄ *Also not far from the Deep Creek trailhead is the beautiful Juney Whank Falls, which continues to cascade over rocks for some distance below the bridge.*

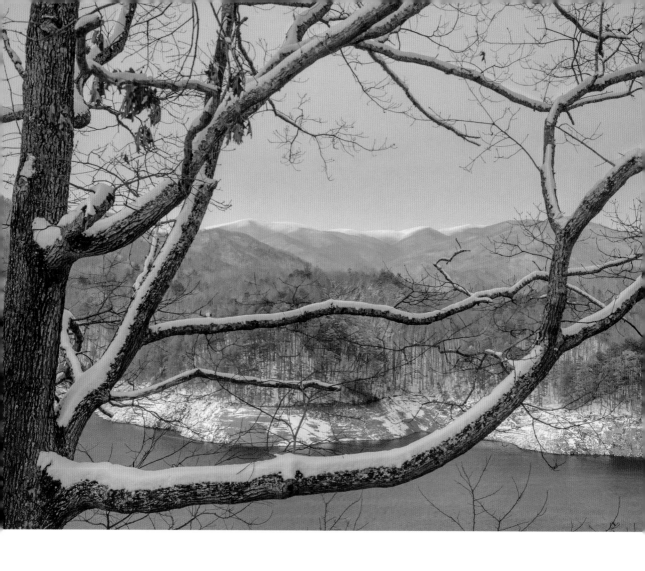

▲ *Some of the highest mountains of the Smokies are seen from a Fontana Lake overlook.*

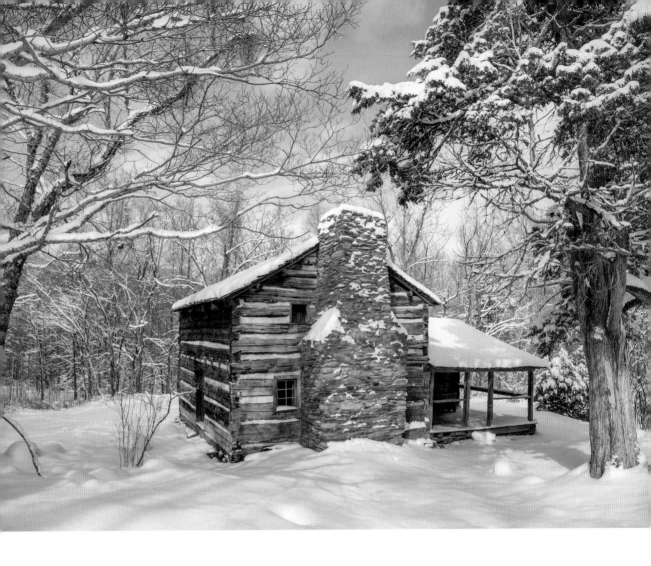

▲ The last residents within the park boundaries lived in the Walker Sisters Cabin until 1964.

(Pages 44–45) This view shows the very popular Chimney Tops before the terrible wildland fire of November 2016 burned all vegetation on the summit ridge.

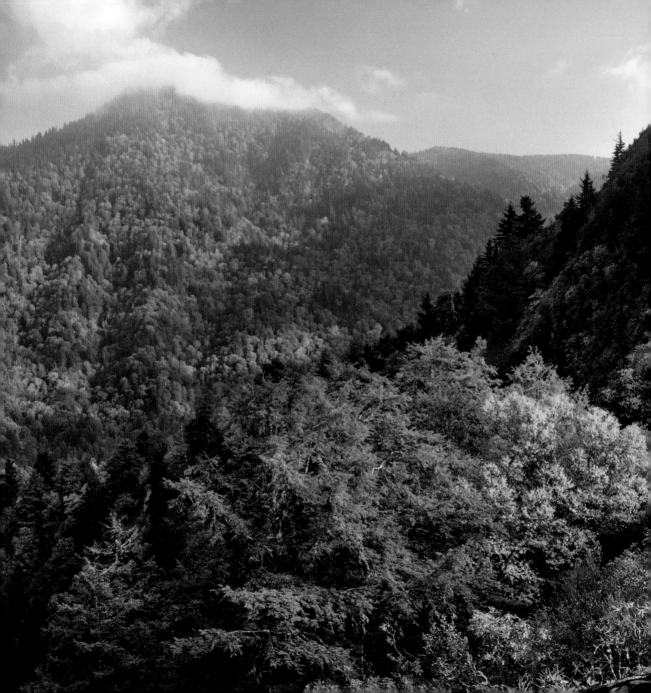

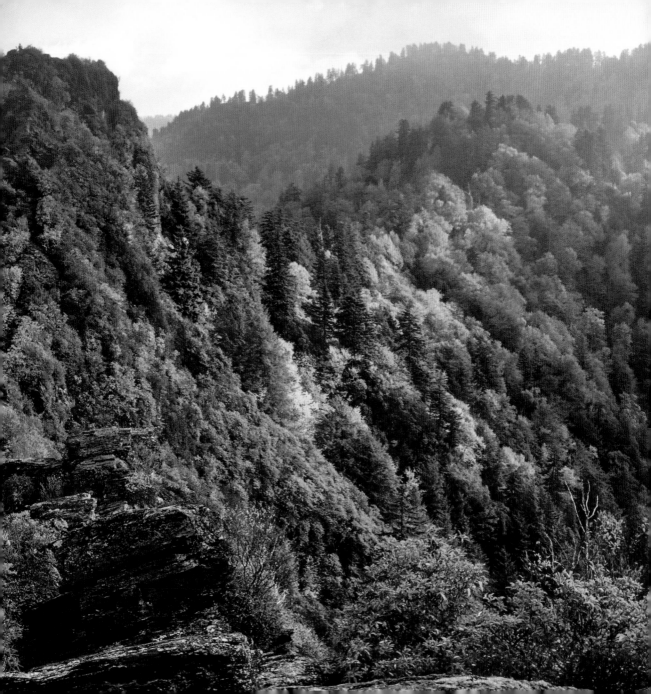

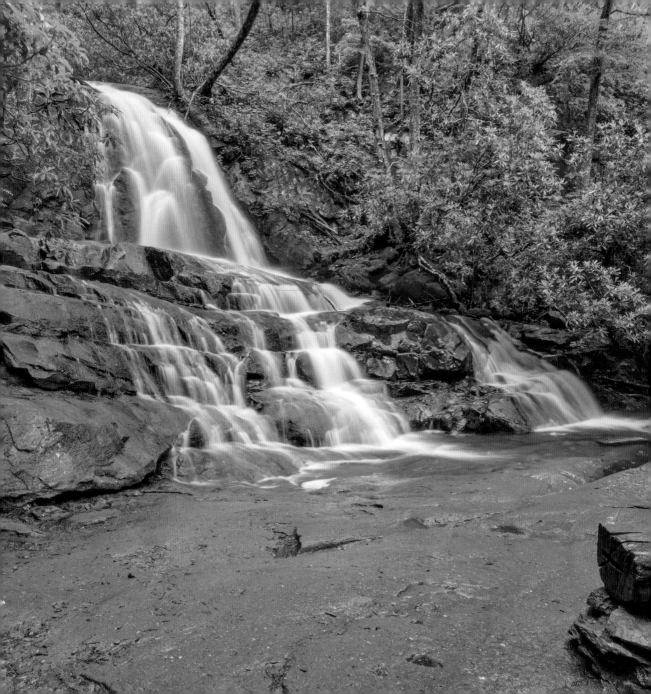

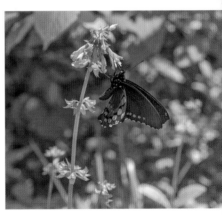

▲ *These unusual tree trunks are along one of the bends on the Little River (top); a yellow swallowtail butterfly feeds on flower nectar in the Cosby area (above left); a pipevine swallowtail feeds on recently opened penstemons (above right).*

◄ *The 80-foot-high Laurel Falls is one of the most popular hiking destinations in the Smokies.*

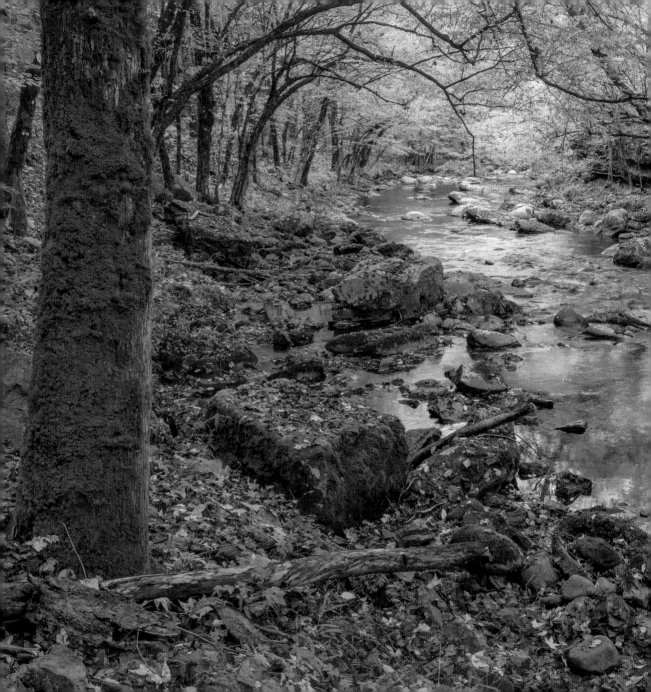

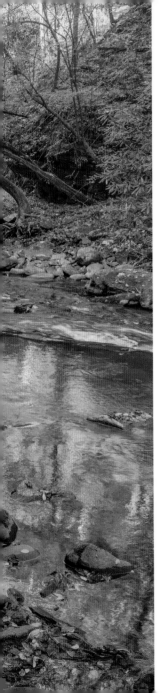

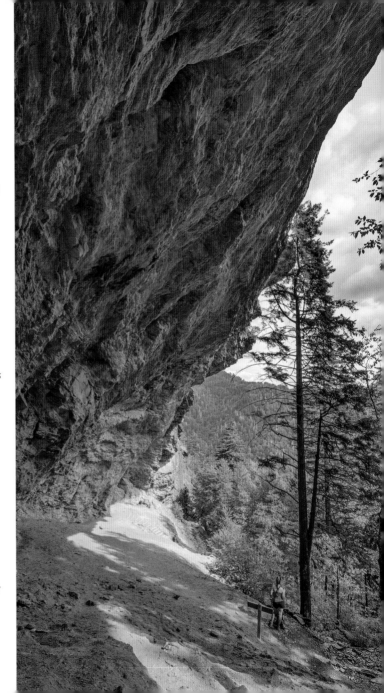

◀ *The Middle Prong sparkles on a beautiful fall day.*

▶ *Alum Cave Bluffs tower overhead at this popular destination along the trail to Mount LeConte.*

(Pages 50–51) Grotto Falls is seen on a rainy spring day.

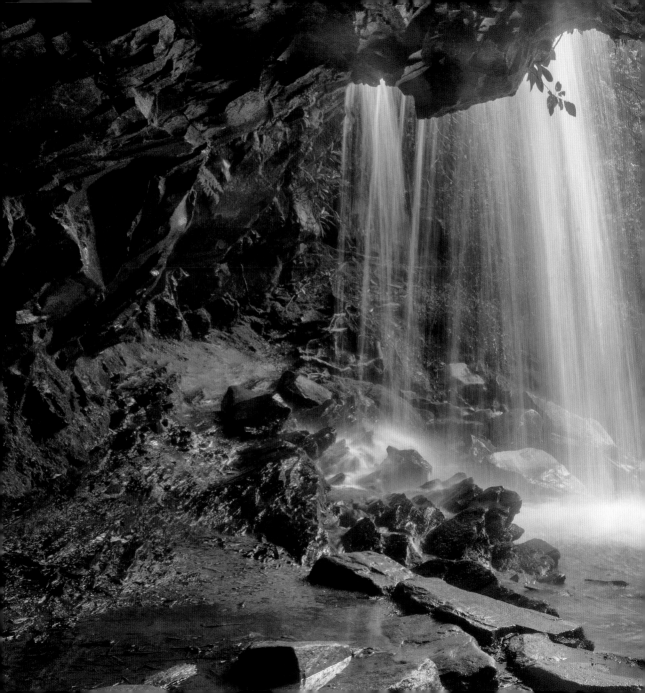

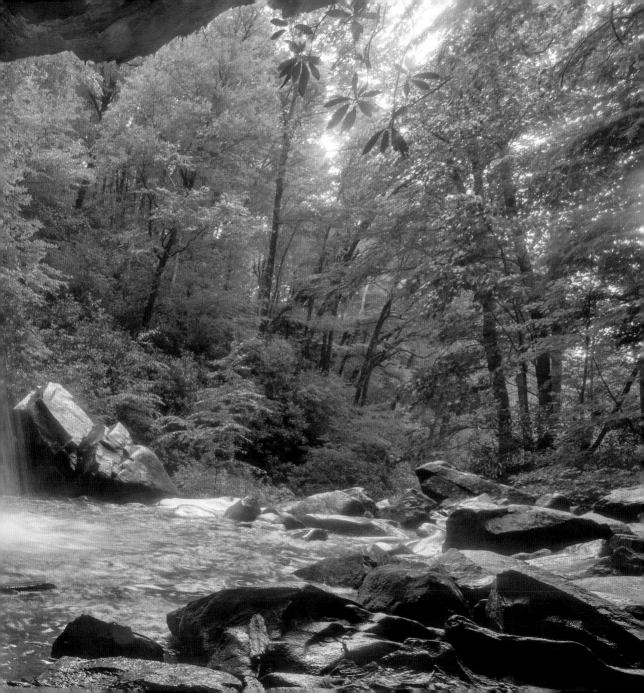

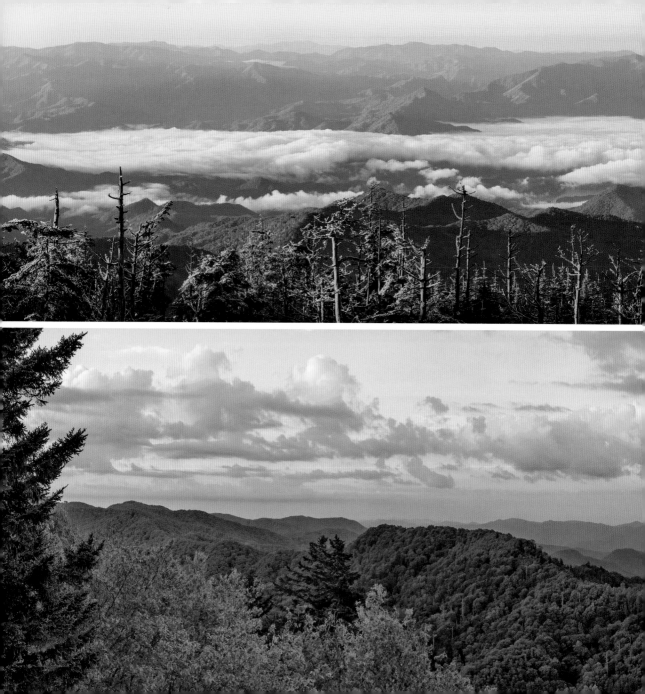

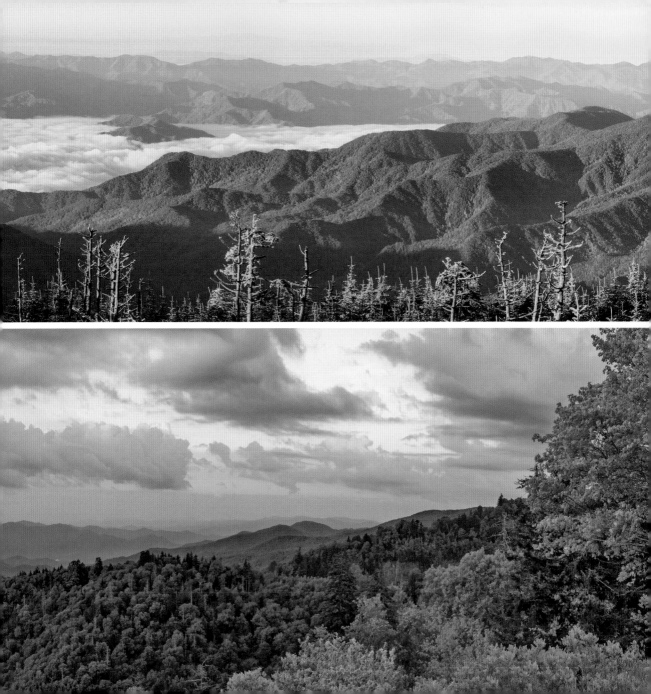

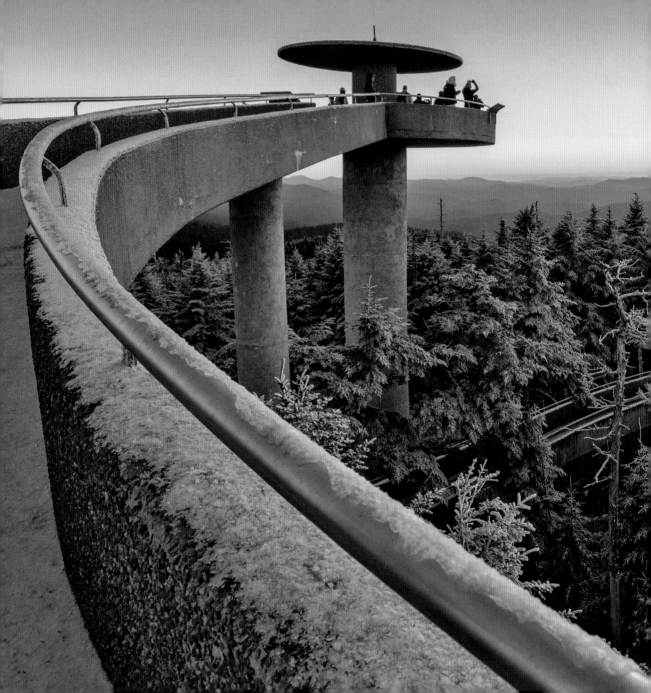

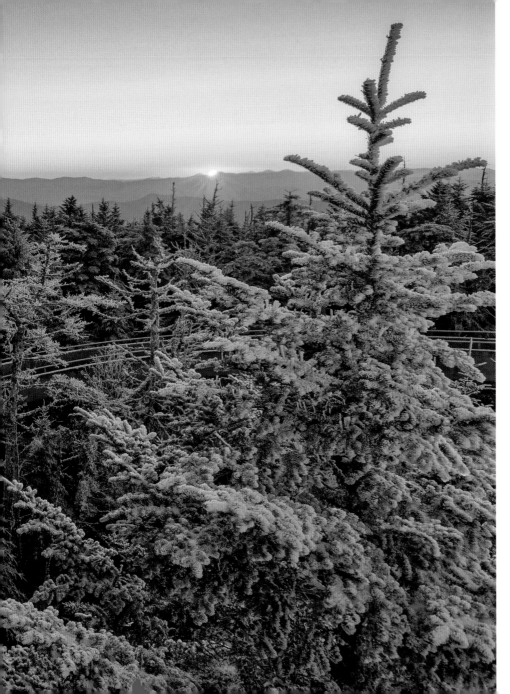

(Pages 52–53) *Sunrise light adds a beautiful drama to the mountainous landscape. The top panorama is the view looking south from the Clingmans Dome tower, and the bottom panorama is the view looking south from the Newfound Gap parking area.*

◀ *At 6,643 feet, Clingmans Dome is both the highest point in the Smokies and the highest point on the Appalachian Trail.*

▲ *The highest summits can see wintry conditions in most months of the year; this snow fell in early May (top); during an October cold snap, ice coats the grass below cliffs along Clingmans Dome Road (above left and right).*

▶ *Sunrise colors the sky above the Great Smoky Mountains, as viewed from the Clingmans Dome parking area.*

(Pages 58–59) Magical mist covers the valleys in the first sunlight of the day, as viewed from the Clingmans Dome parking area.

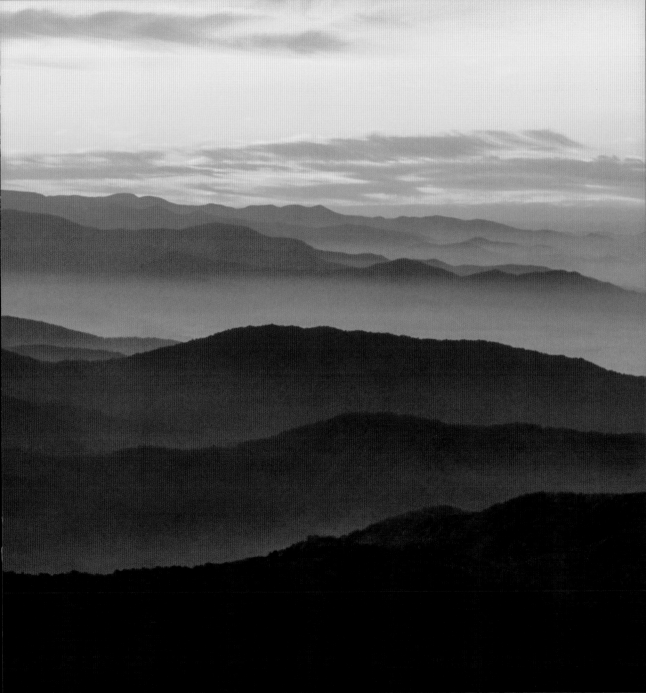

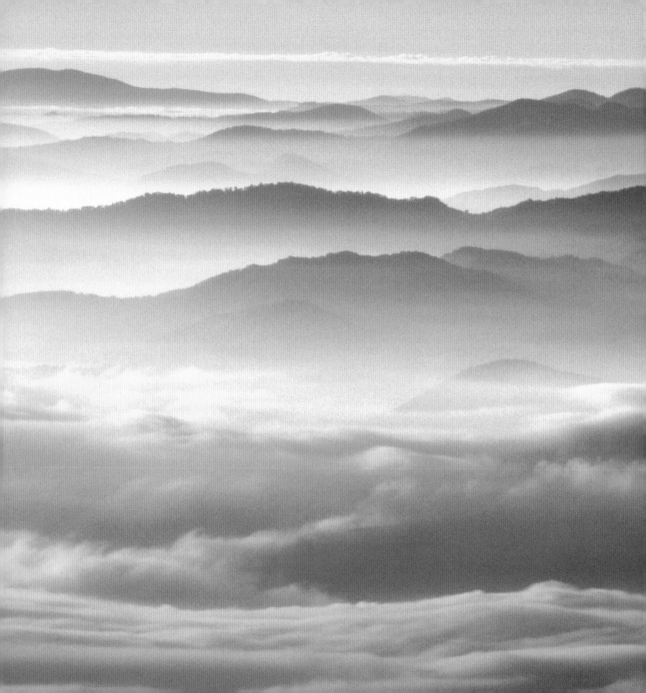

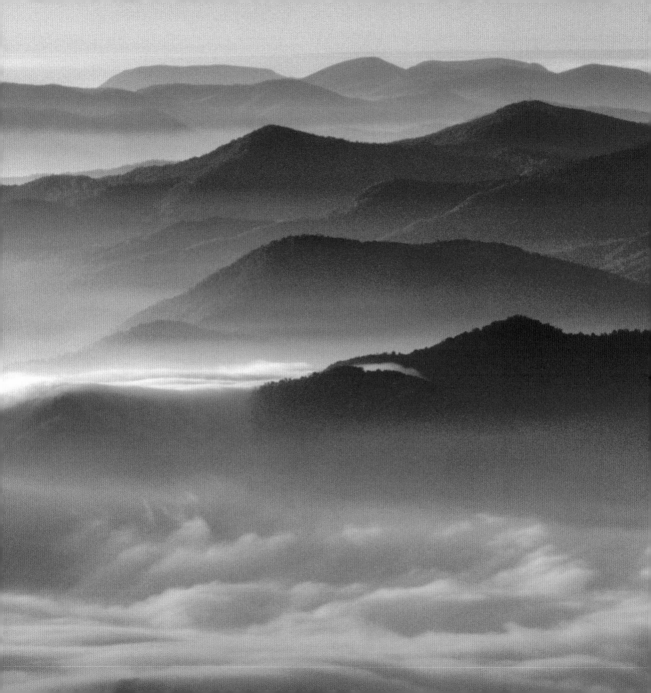

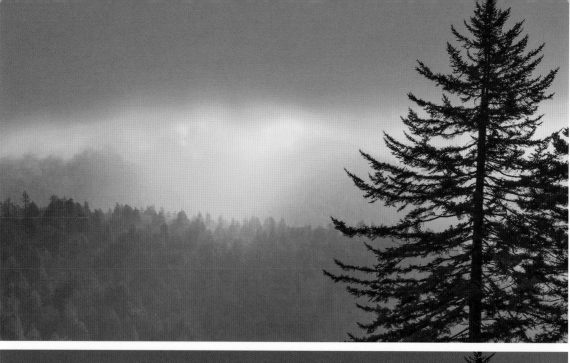

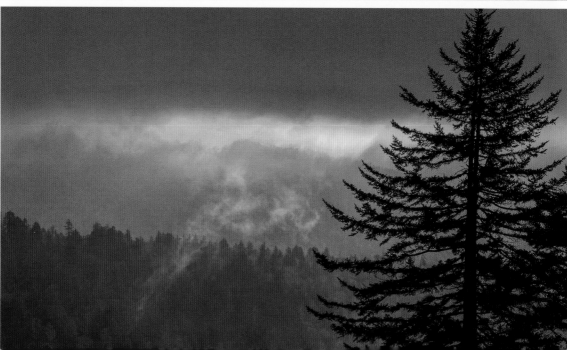

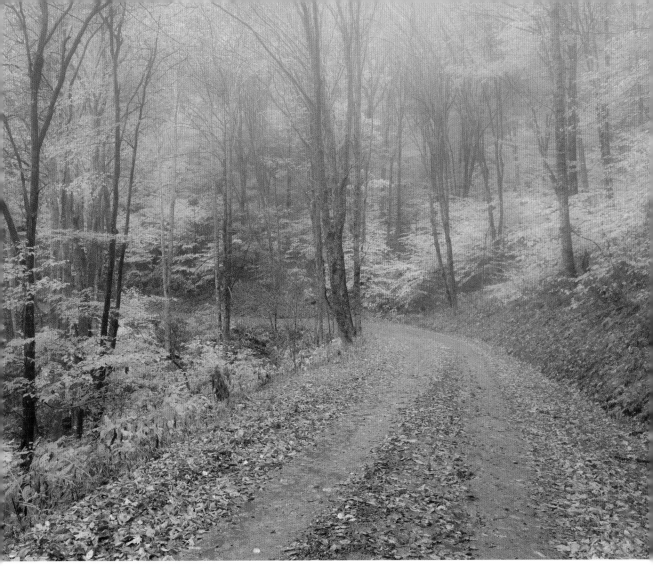

▲ *Leaves fall on the Balsam Mountain drive on a misty autumn day in late October.*

◀ *The changing tones of morning light from just below cloud level are visible at an outlook along Clingmans Dome Road.*

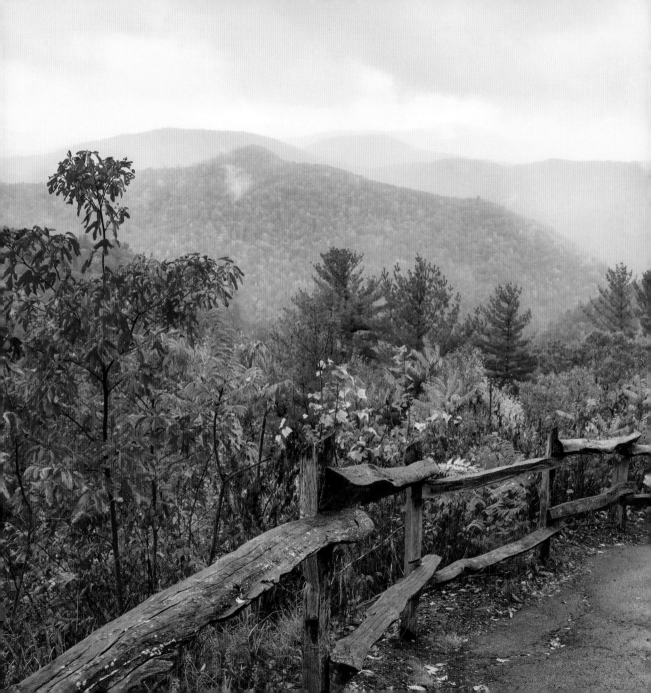

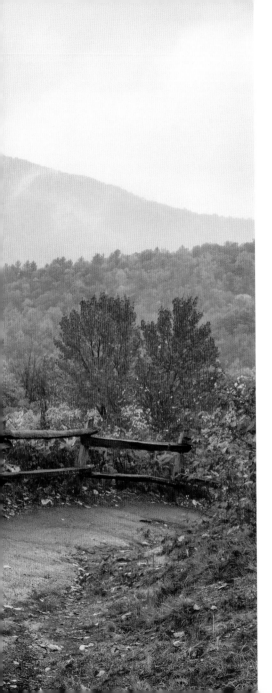

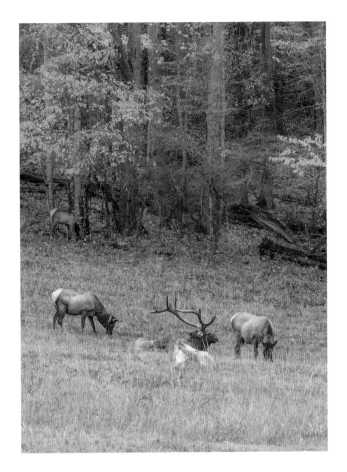

▲ *American elk can often be seen at the Oconaluftee Visitor Center fields, as well as fields in the Cataloochee Valley.*

◀ *Vibrant fall colors are visible from the Cataloochee Valley overlook.*

(Pages 64–65) A summer afternoon rainbow arcs above the fields at the Oconaluftee Visitor Center.

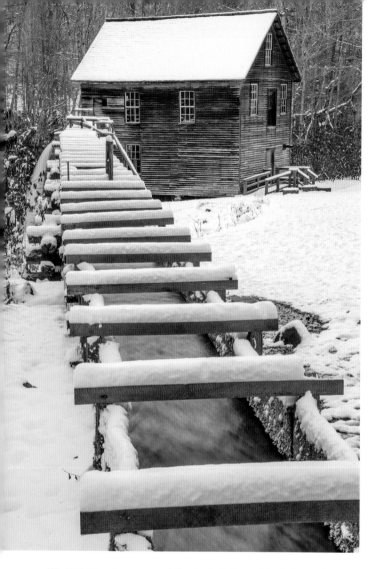

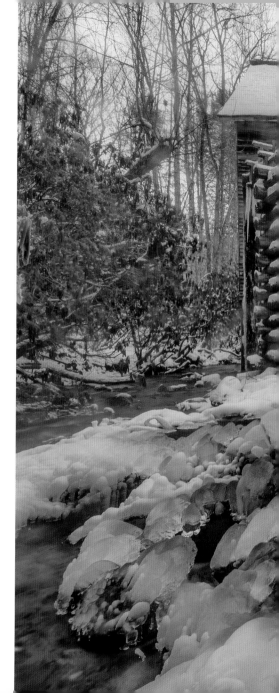

Winter temperatures can reach the single digits or colder during a winter cold snap, creating lots of great ice formations below the falling waters of the Mingus Mill millrace.

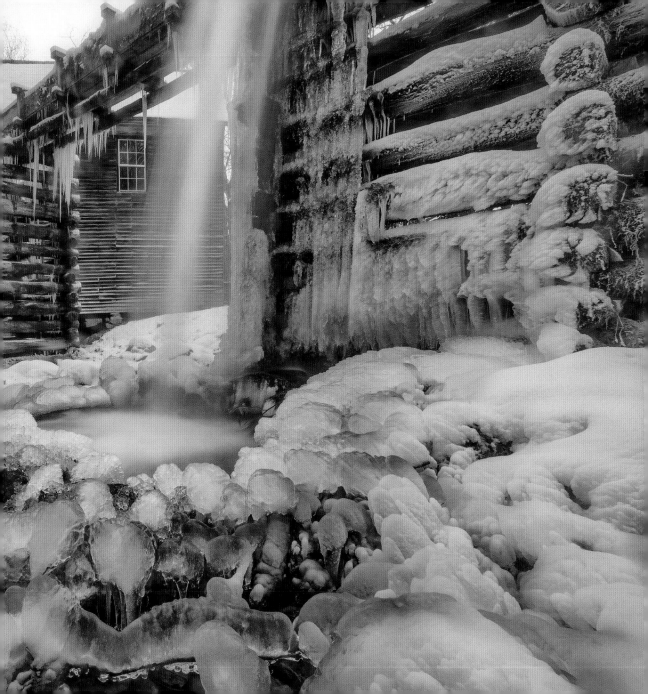

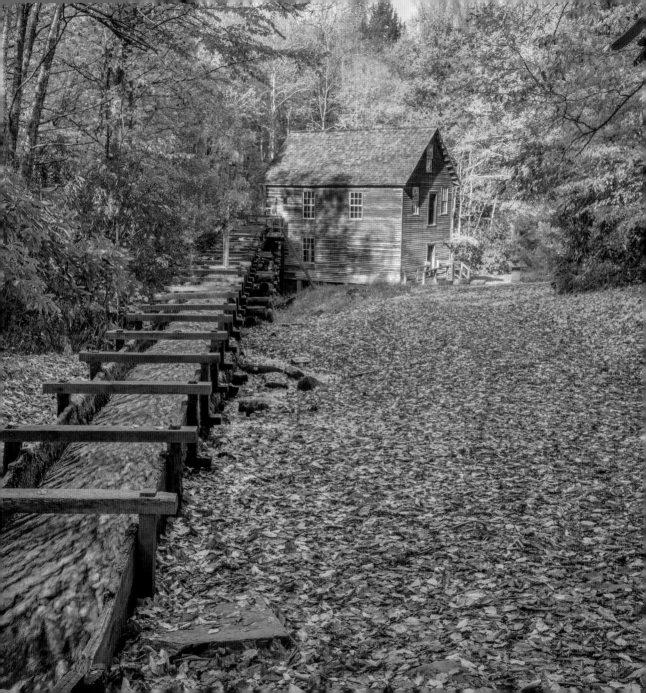

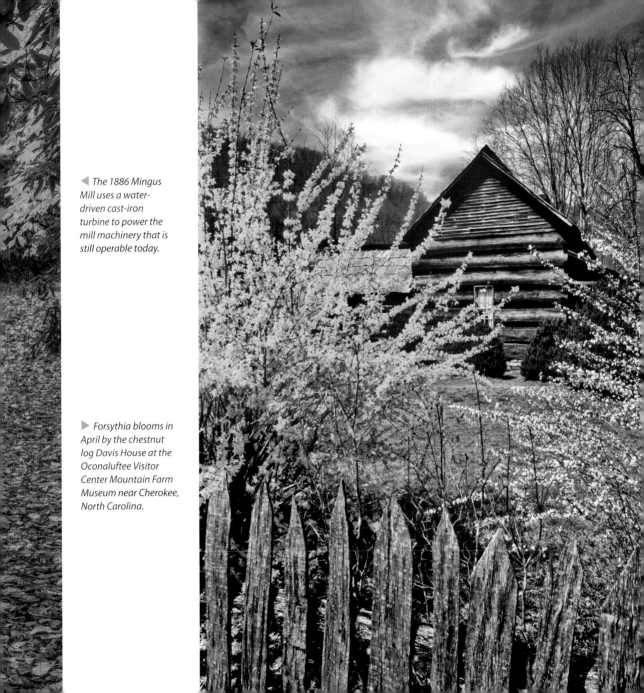

◀ *The 1886 Mingus Mill uses a water-driven cast-iron turbine to power the mill machinery that is still operable today.*

▶ *Forsythia blooms in April by the chestnut log Davis House at the Oconaluftee Visitor Center Mountain Farm Museum near Cherokee, North Carolina.*

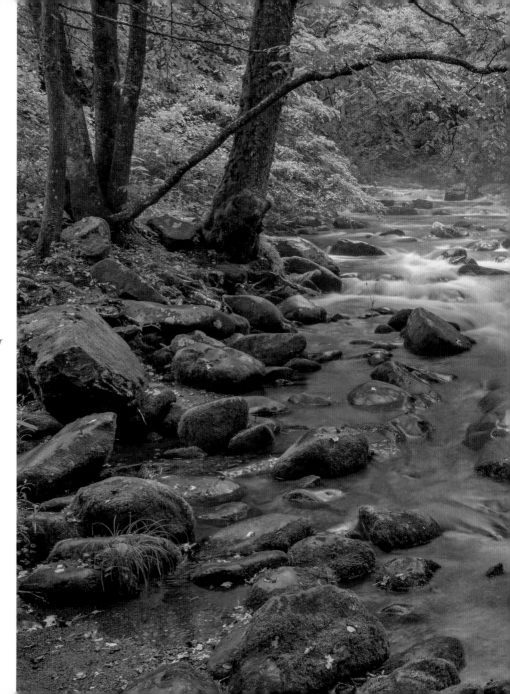

*The Oconaluftee River
swells after a rain.*

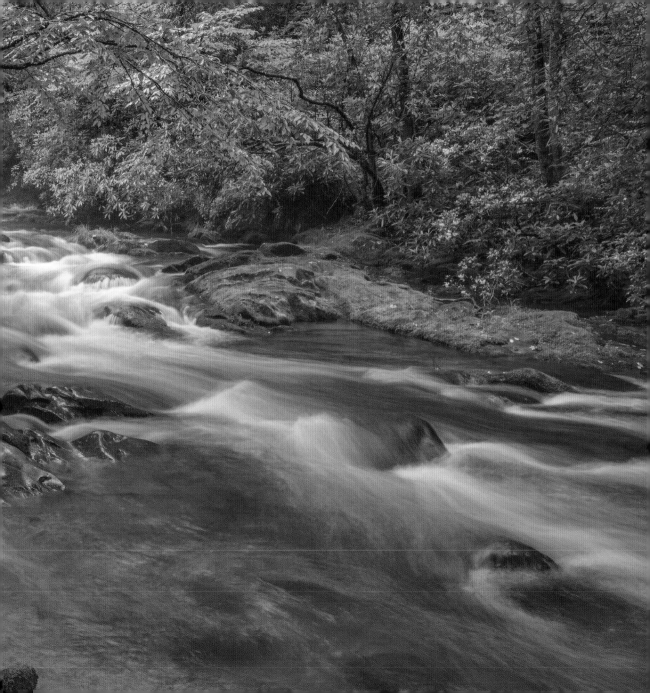

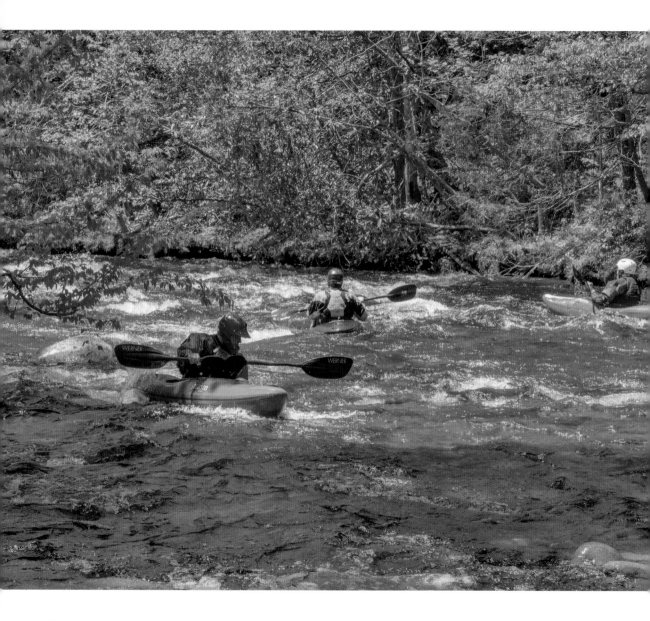

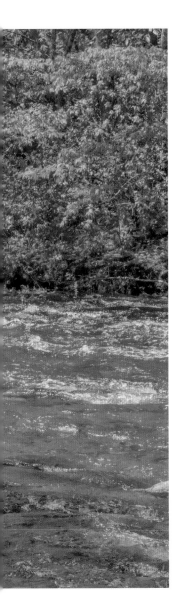

◀ *Kayakers enjoy the Little River on a spring day.*

▶ *One of many huge moss-covered old-growth trees in Great Smoky Mountains National Park, this one is along the Porters Creek Trail.*

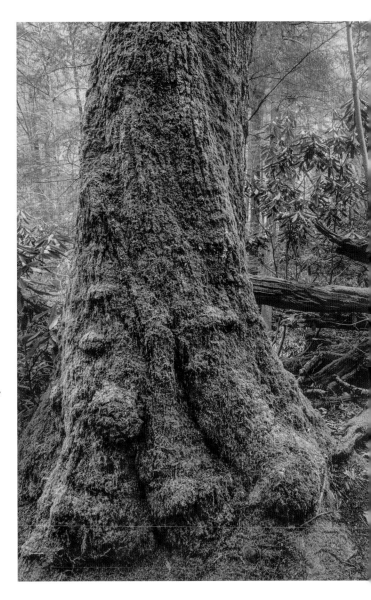

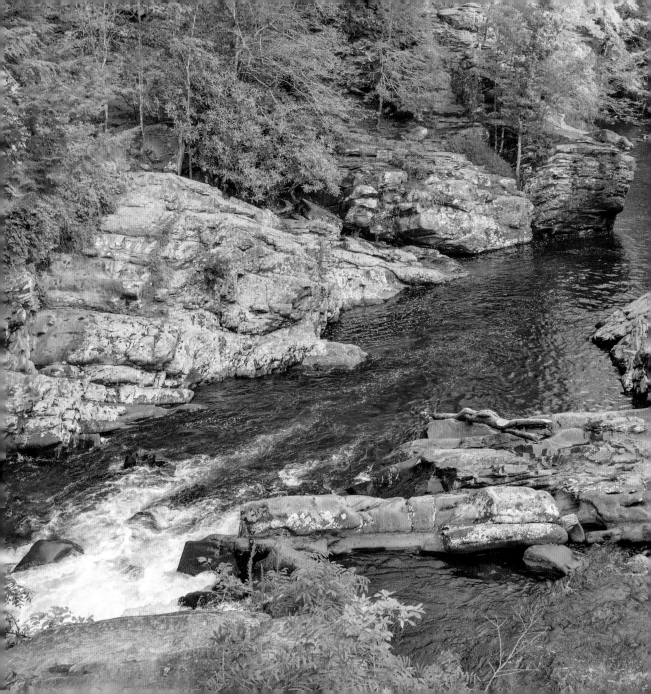

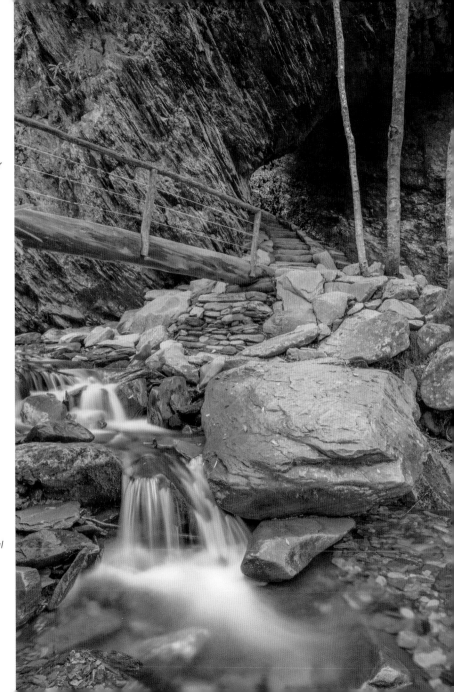

◀ The Sinks is a very popular summer destination on the Little River.

▶ The footbridge over Styx Branch, at Arch Rock, is on the trail to Alum Cave Bluffs and Mount LeConte.

(Pages 76–77) Hepatica covers a Smoky Mountains hillside on a beautiful spring day in mid-April.

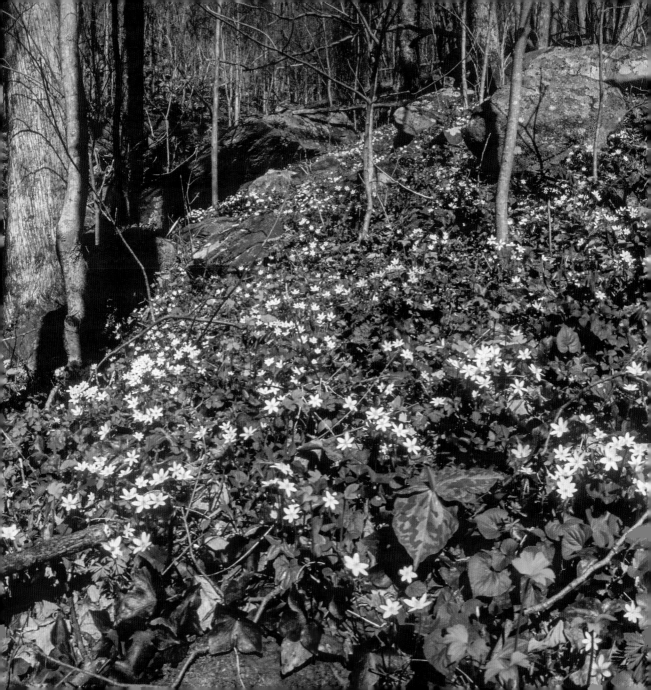

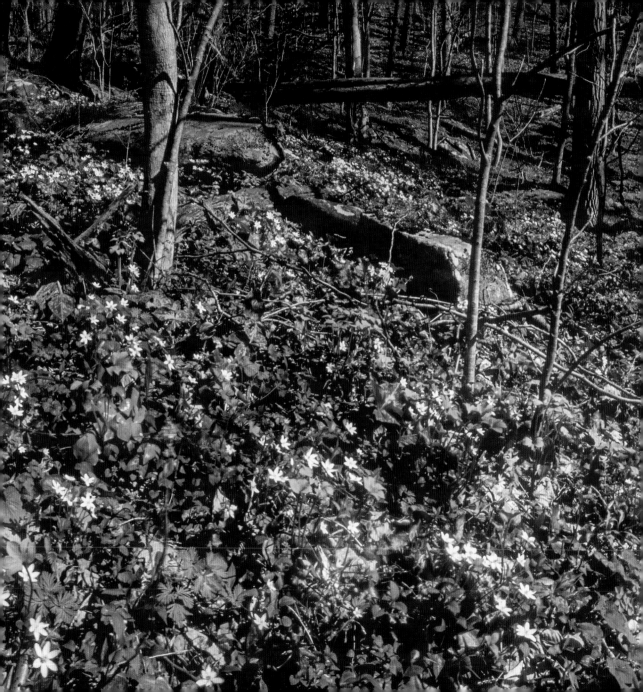

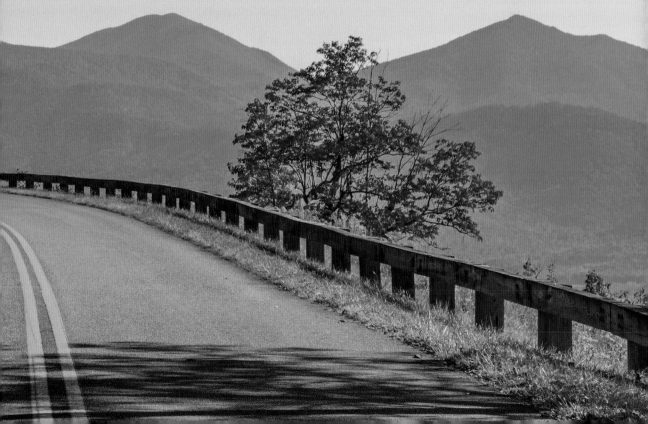

BLUE RIDGE
PARKWAY

Blue Ridge Parkway

THE BLUE RIDGE PARKWAY IS NOT THE MEANS TO AN END; it is the destination as well as the journey. Each time I turned onto the parkway from a main highway, I felt transported to a different place and time. The parkway is as peaceful, quiet, relaxing, and close to nature as a person can get while driving a car. If you're a person who enjoys being in the mountains and driving along winding rural and backcountry roads, you'll love traveling along the 469-mile length of the Blue Ridge Parkway.

Driving on the parkway for the first time is a continuous discovery. Every turn in the road and overlook brings a completely new experience. A second trip brings along some familiarity with places visited before, but also invites thoughts of new places to stop and explore. The main route itself is magnificent to travel as it passes through forests and farmlands, past spectacular vistas, and then traverses along the highest edges of the Blue Ridge crest, where the mountainsides drop steeply to river valleys 3,000 feet below.

Different seasons and varying weather offer additional moods and dimension. Clouds and fog may obscure the roadway in one area, while a view above it all opens up in another. The almost constant change in road elevation adds diversity in views as well as habitat. The long-distance Appalachian Trail and Mountains-to-Sea Trail follow the Blue Ridge along the parkway, and there are many other shorter trails that can be hiked to waterfalls, mountaintops, rocky outcroppings, secluded valleys, and historic sites.

(Pages 78–79) From the Black Horse Gap area at MP 97.5, travelers can glimpse the Peaks of Otter.

▶ *Late afternoon light bathes the beautiful rolling hills at MP 285 near Boone, North Carolina.*

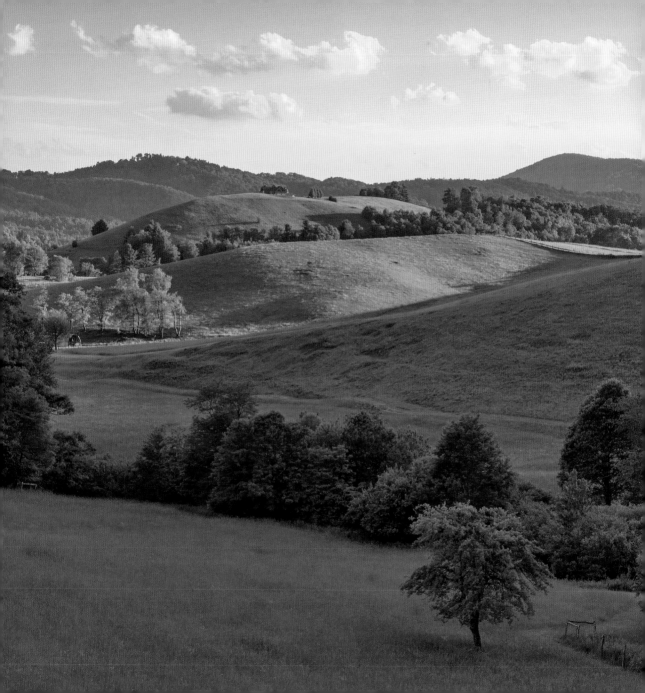

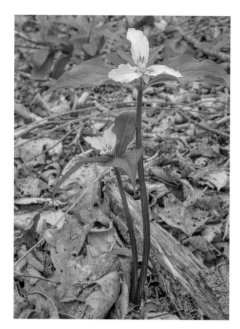

▲ *Painted trillium blooms along the trail to Crabtree Falls on an early May afternoon.*

▼ *I moved this box turtle to the woods after I found it in the middle of my parkway lane.*

▶ *Beautiful Yellowstone Falls, the lower and easiest access of the two waterfalls at Graveyard Fields, MP 418.8, shimmers on a spring day.*

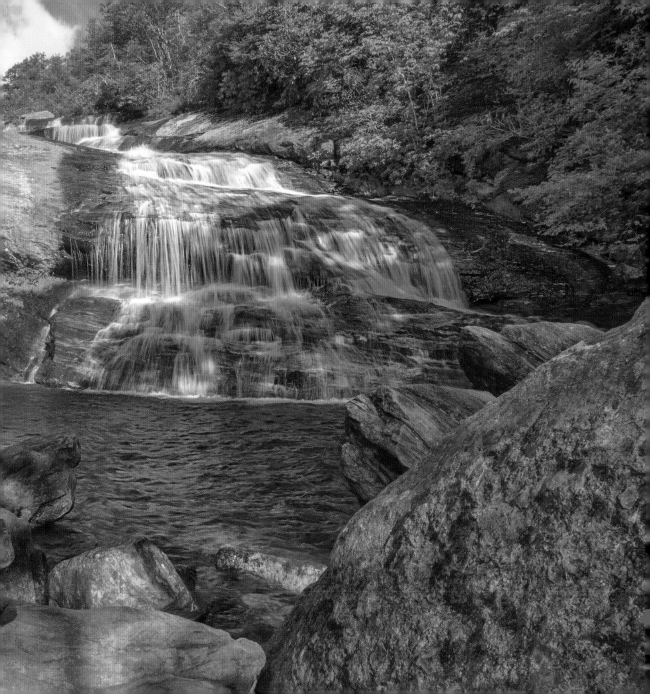

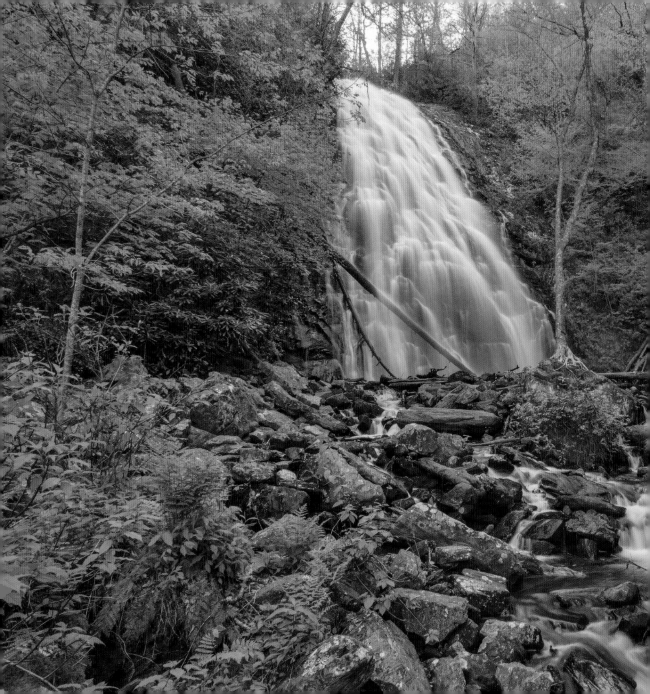

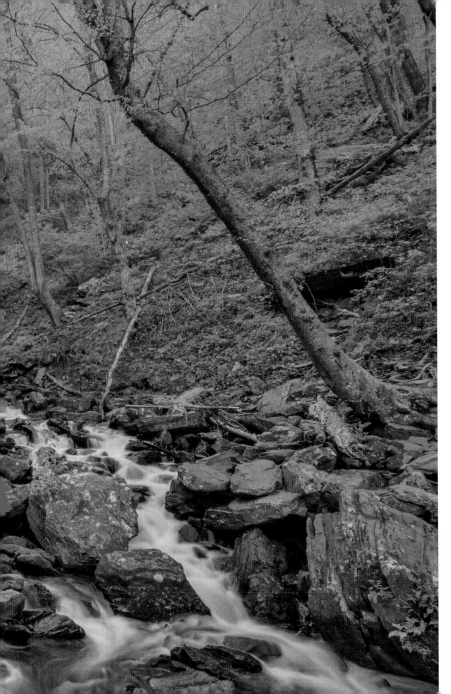

The 70-foot-high Crabtree Falls is a popular hiking destination from the campground at MP 339.5.

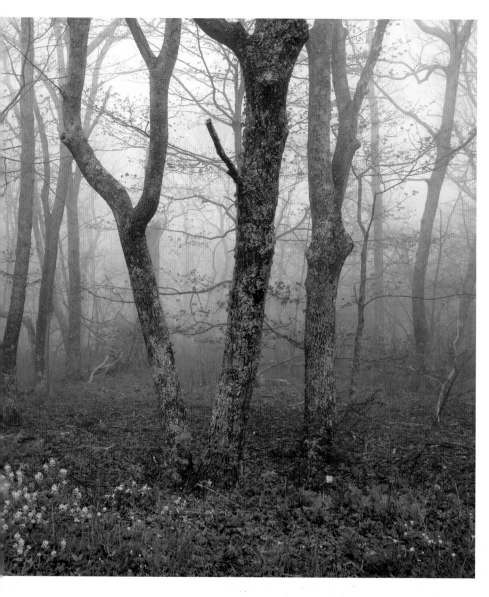

◀ While fog can be so thick that it's impossible to drive after dark, this fog is in soft morning light around MP 75.

▶ A break in the rain opens up a view of the fog-filled mountains and valleys of the Blue Ridge behind the dogwoods blooming at the Jeffress Park Cascades Trail parking area.

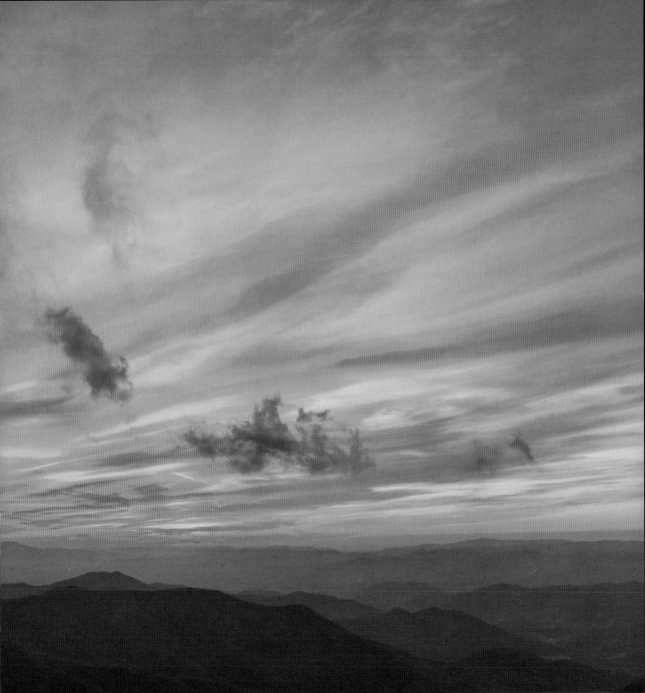

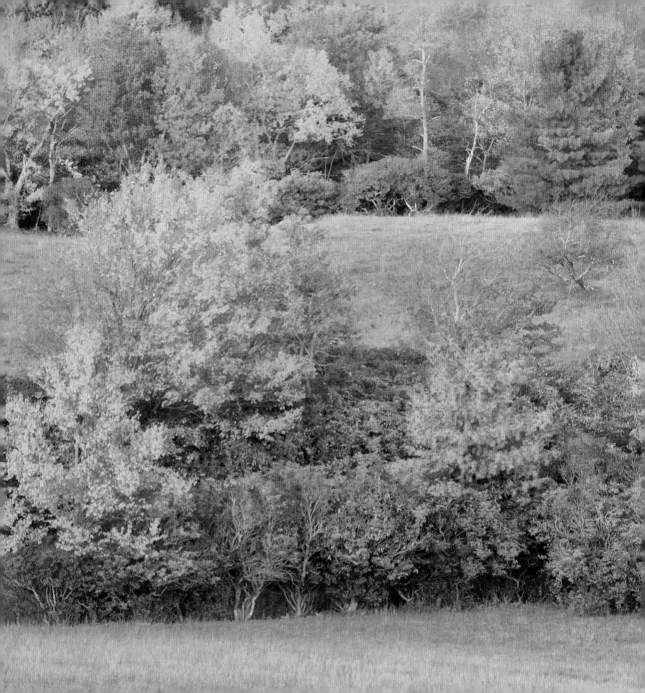

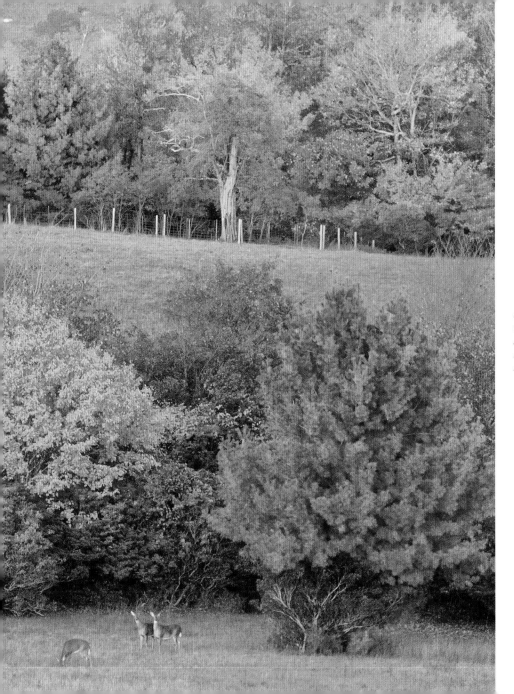

Deer walk through the fields of the Bluff Mountain area in Doughton Park not long after sunset.

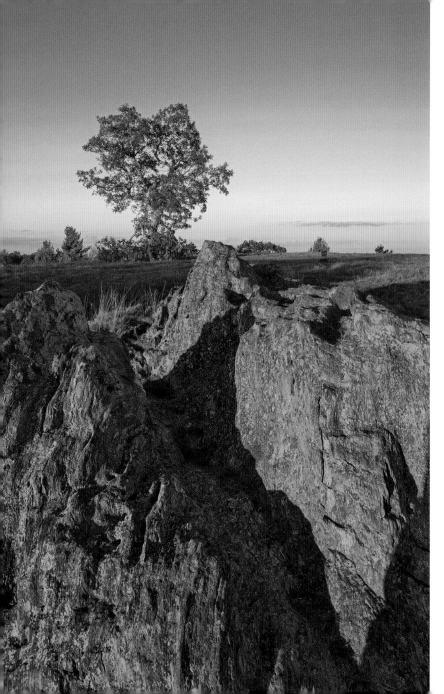

Both of these photos were taken from the same rock outcropping on Bluff Mountain in Doughton Park at MP 241. The left photo looks north to a single tree on the grassy hillside, and the right photo looks west to the sun settling into the Blue Ridge Mountains.

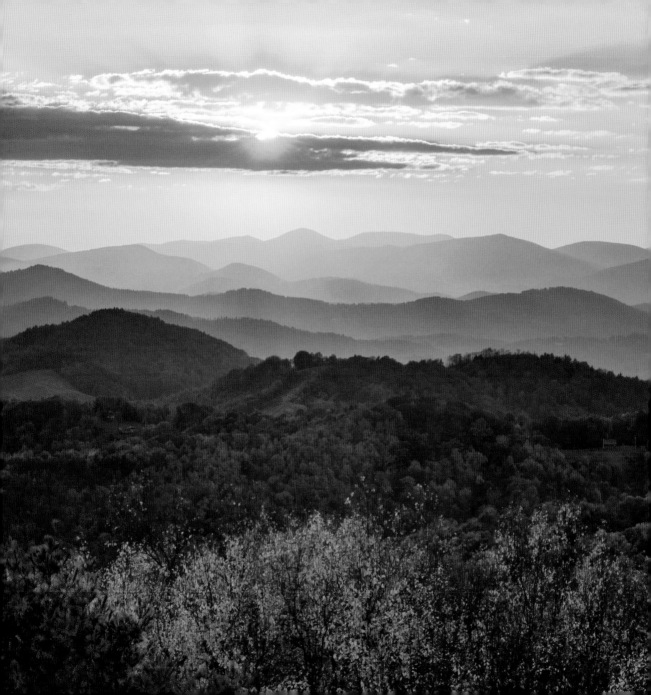

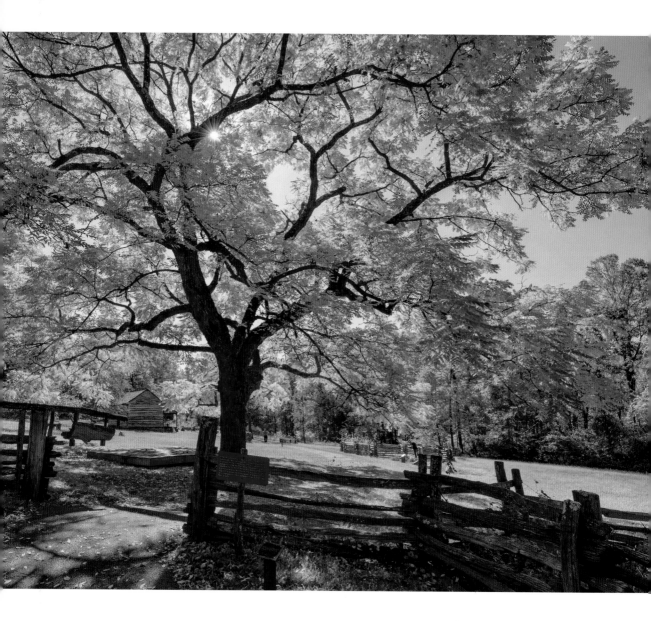

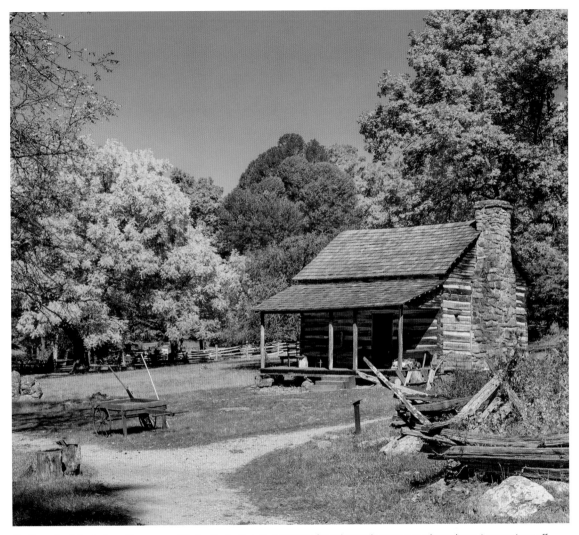

The Humpback Rocks Farm Museum and Visitor Center is a short distance from the north entrance to the parkway. Interpretive staff members are on hand to answer questions as people tour the historic buildings. This is also the trailhead area for the popular hike up to the rocky outcropping of the same name.

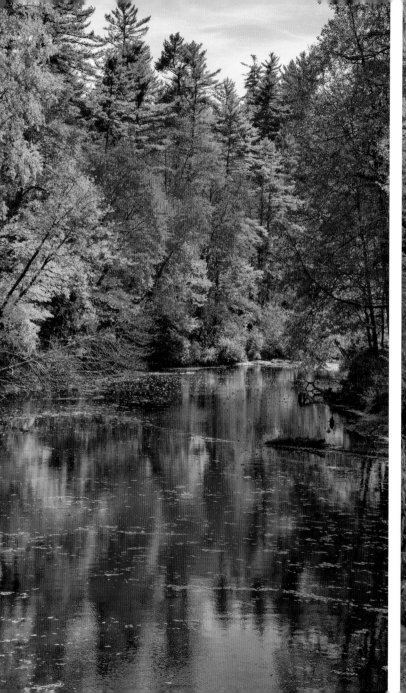

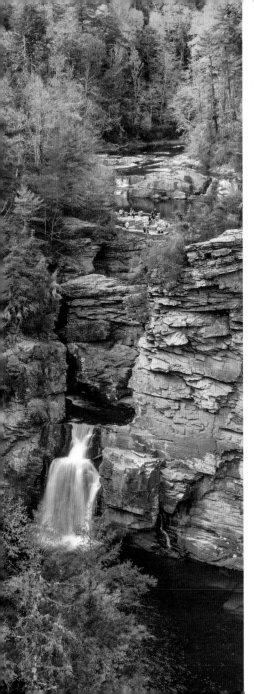

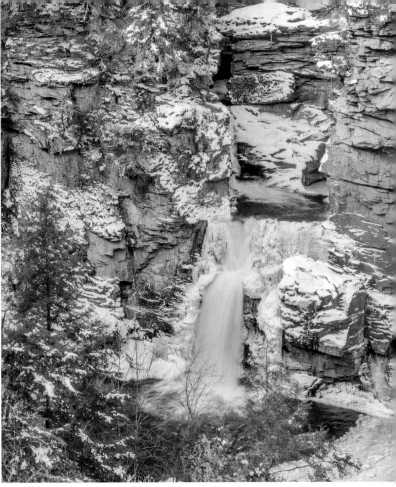

The Linville Gorge is one of several designated wilderness areas along the parkway. Two main trails from the visitor center at MP 316 provide access to sites both above and below the falls. Erwins View Trail has views from the bridge over the Linville River (far left) and views of the falls from the Chimney View Overlook in both autumn (left) and winter (above).

(Pages 104–105) The Linville Gorge Trail gives access to the river below the waterfall, with great views looking upstream to the gentle cascades, impressive falls, and huge pool of water at the base.

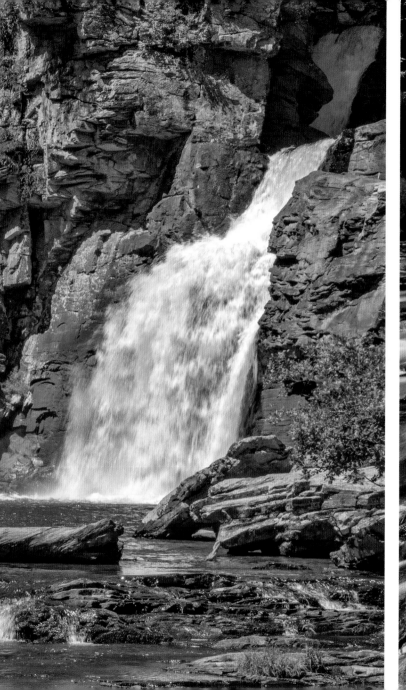
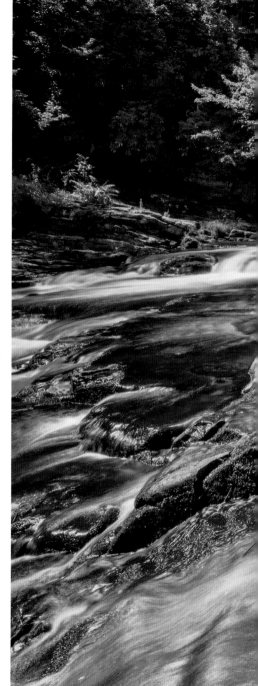

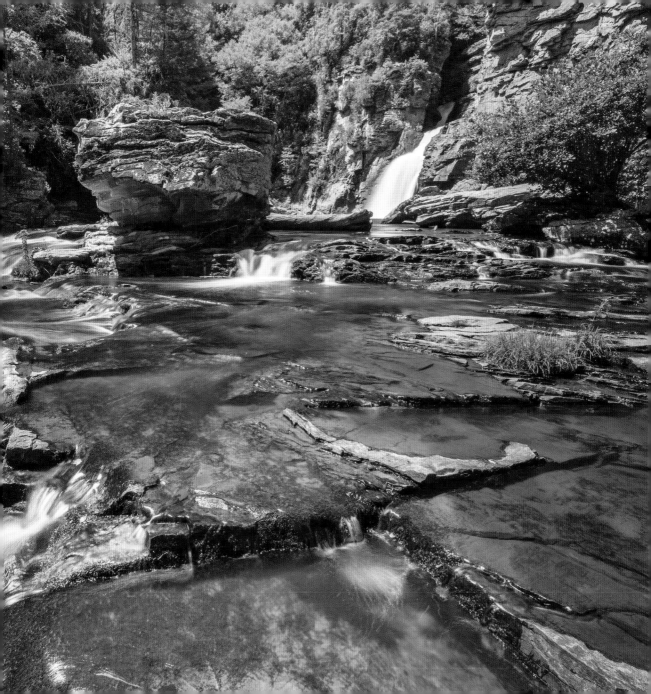

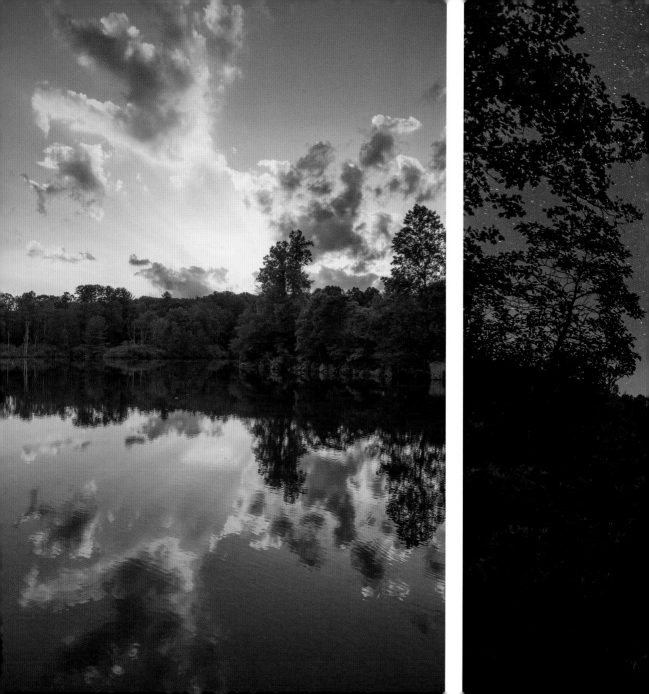

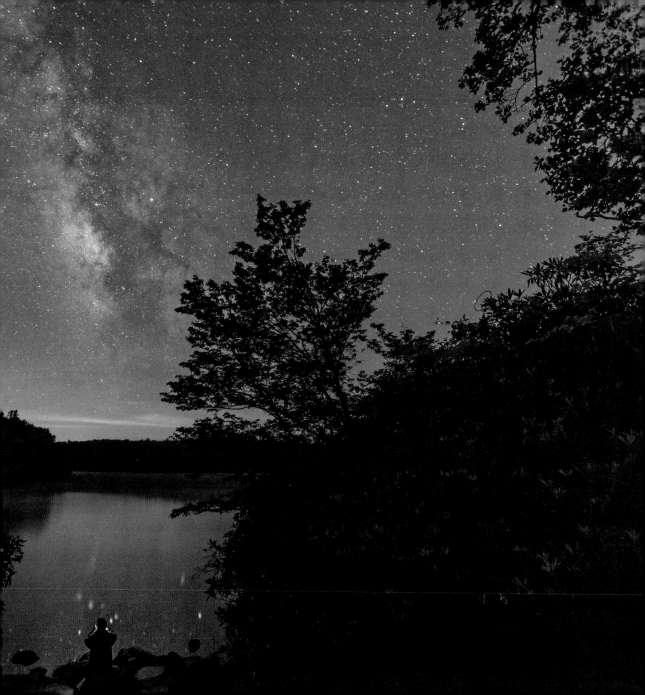

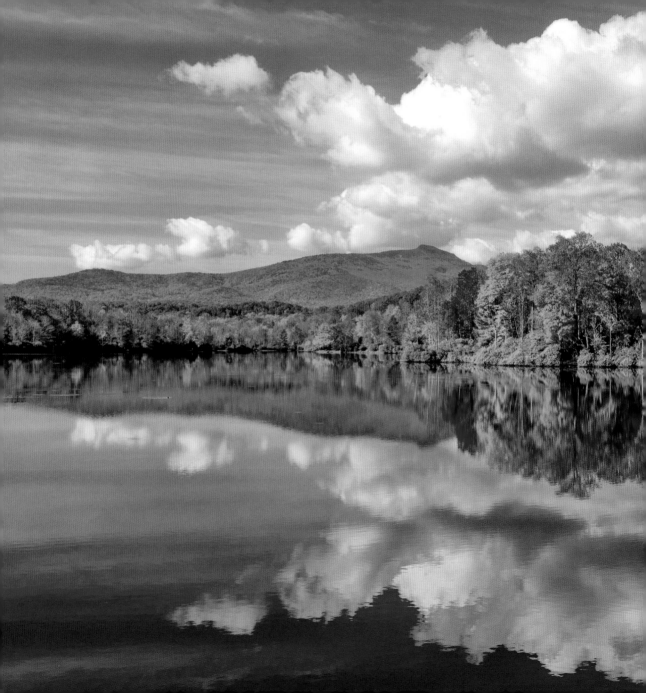

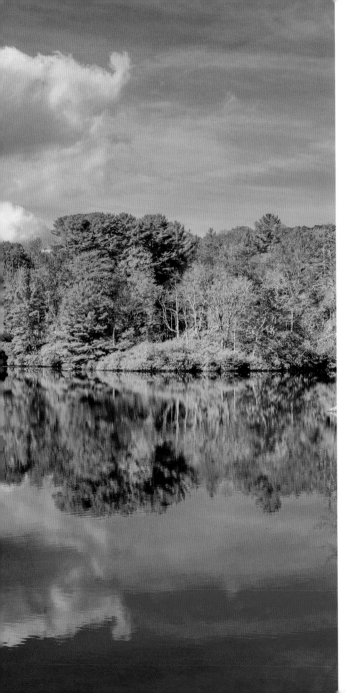

(Pages 106–107) *Price Lake in the Julian Price Memorial Park, MP 297, is a beautiful body of water right along the parkway. It's a wonderful place to hike, fish, or photograph, in any season and at any time of day. The sun sets over the lake in springtime (left), and a photographer captures the Milky Way over the lake at night (right).*

◀ *Grandfather Mountain is reflected in the calm waters of Price Lake on a spectacular day in late October.*

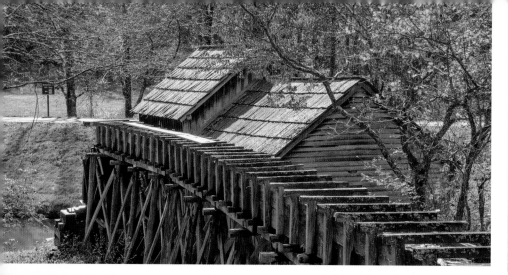

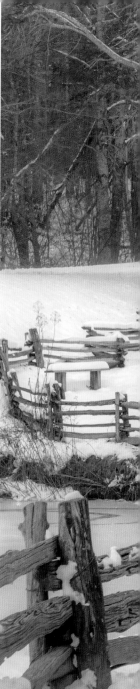

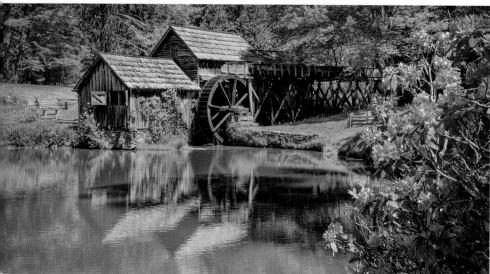

The picturesque Mabry Mill at MP 176 is perhaps the most-photographed location along the Blue Ridge Parkway. In addition to the original working mill and blacksmith shop structures, the Matthews hewn-log house and other historic artifacts are a short distance from the visitor center.

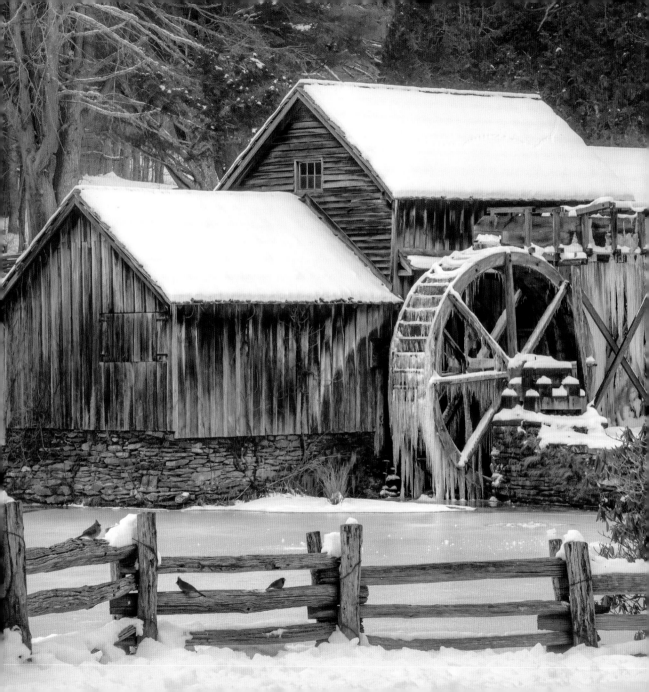

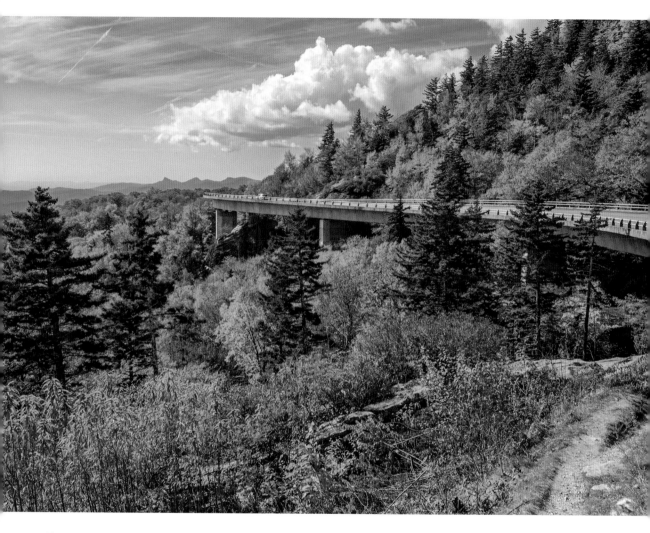

The Linn Cove Viaduct at MP 304 was the last section of the parkway to be completed in 1983. The viaduct is one of the most complicated concrete bridges ever built and is quite the sight to see. It's a challenge to not be distracted by the mountainous view as the roadway winds around the rocky flanks of Grandfather Mountain.

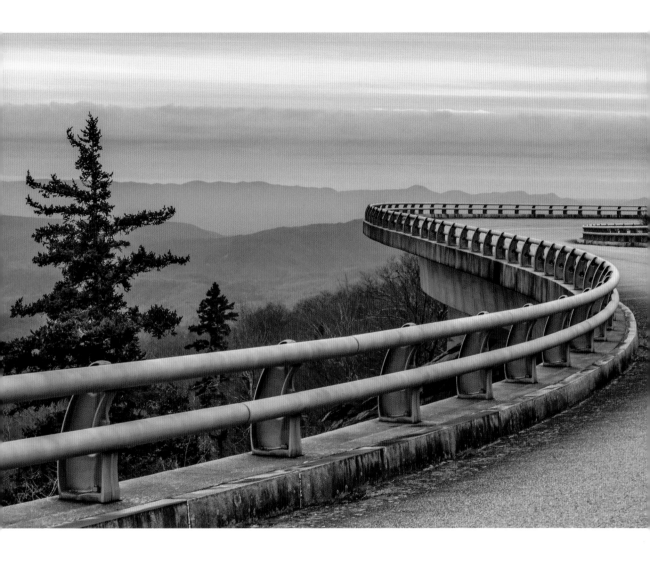

▶ *Horses by the Moses Cone Memorial Park carriage house are all saddled up and ready to ride along the many carefully graded carriage paths on the historic Flat Top Manor estate.*

▼ *Canoeists, paddleboarders, kayakers, and fishermen enjoy a beautiful summer day at Price Lake.*

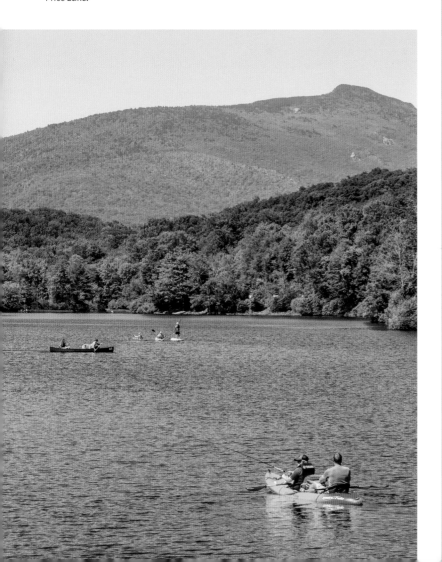

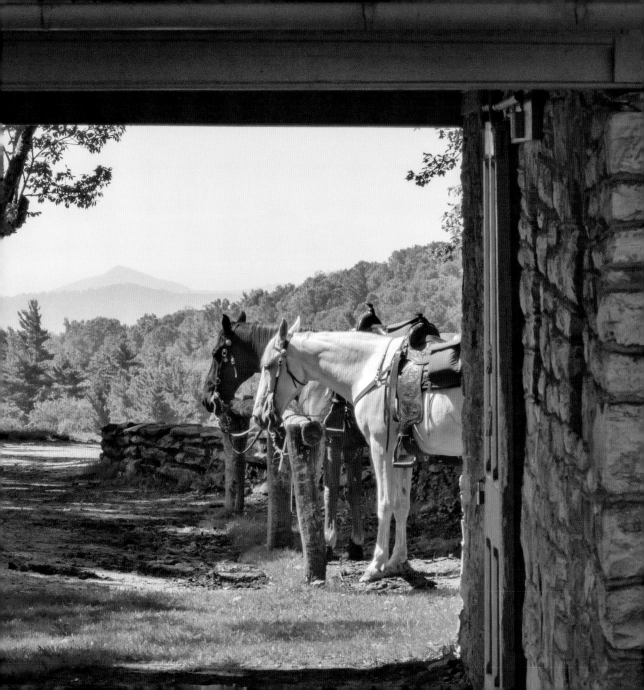

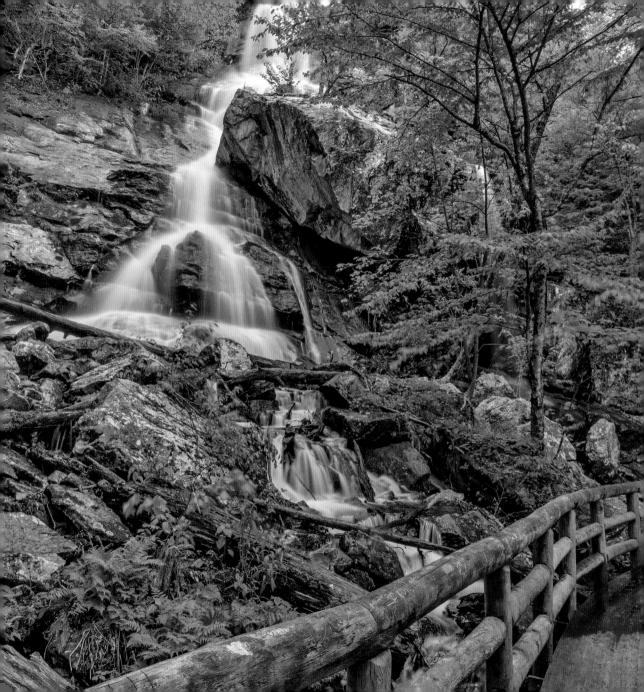

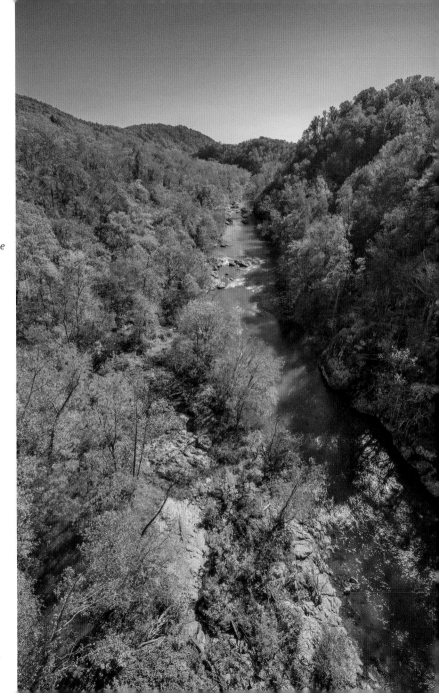

◀ *The 200-foot-high Apple Orchard Falls is quite a sight from the rustic Forest Service bridge over the cascades at the base of the falls.*

▶ *Looking east from the parkway bridge is a beautiful view along the Roanoke River Gorge.*

From the moonlit summit of Sharp Top Mountain, the lights of Lynchburg, Virginia, glow to the east.

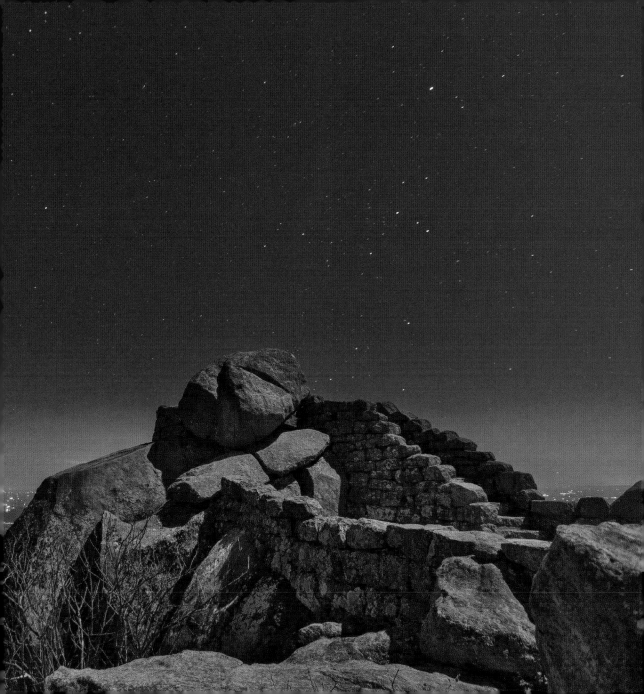

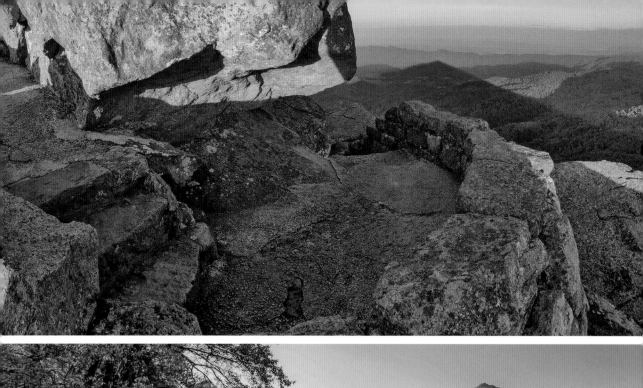

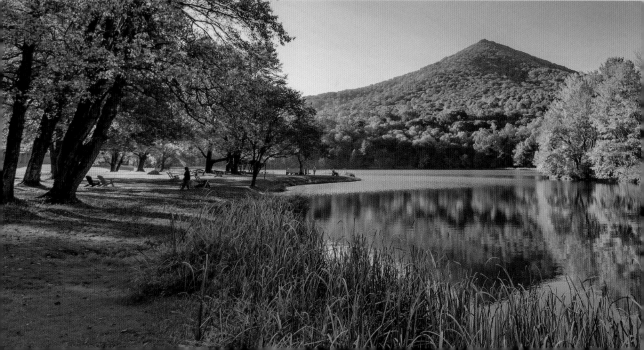

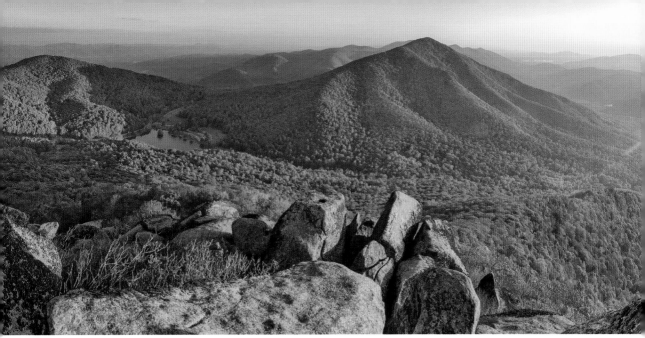

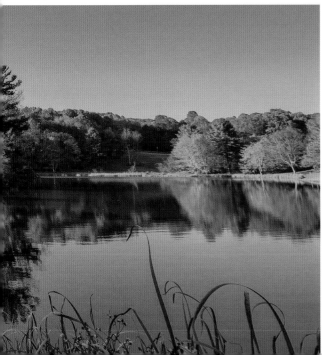

▲ *The 3,862-foot-high summit of Sharp Top has spectacular views over the Peaks of Otter area. Harkening Hill is to the left of the lake, and Flat Top Mountain is to the right.*

◀ *Sharp Top Mountain is viewed from the shore in front of the lodge at Abbott Lake.*

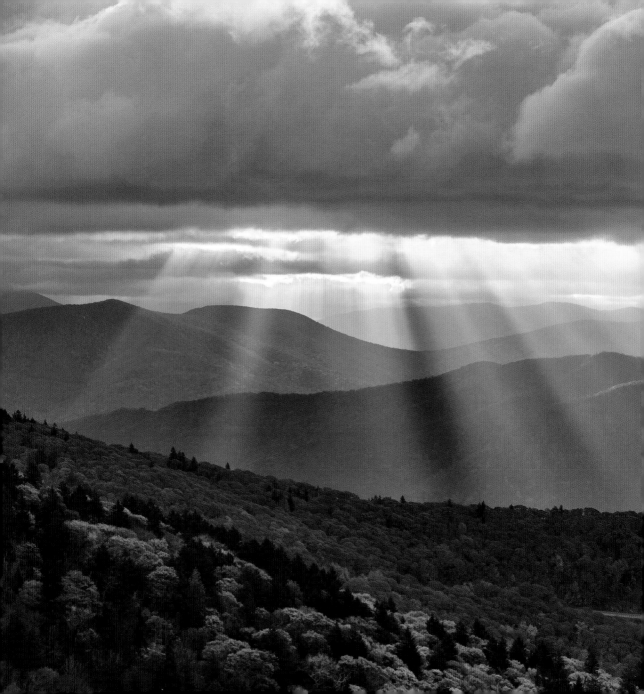

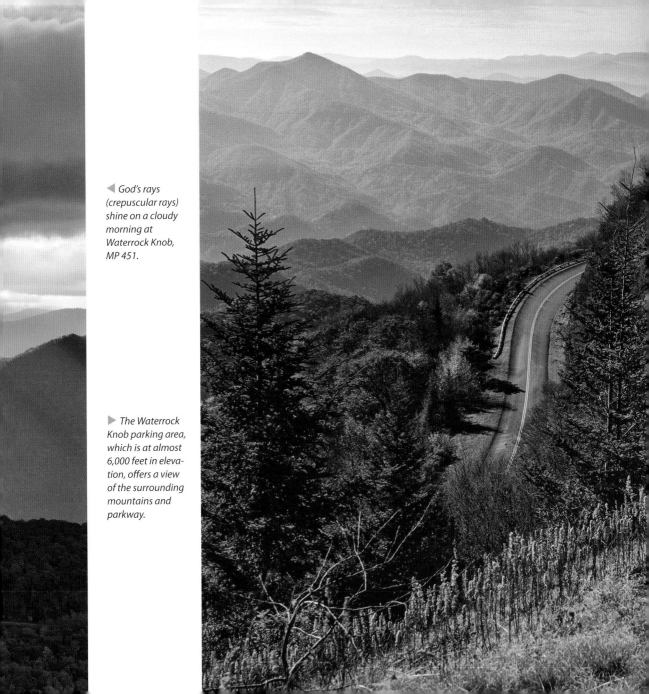

◀ *God's rays (crepuscular rays) shine on a cloudy morning at Waterrock Knob, MP 451.*

▶ *The Waterrock Knob parking area, which is at almost 6,000 feet in elevation, offers a view of the surrounding mountains and parkway.*

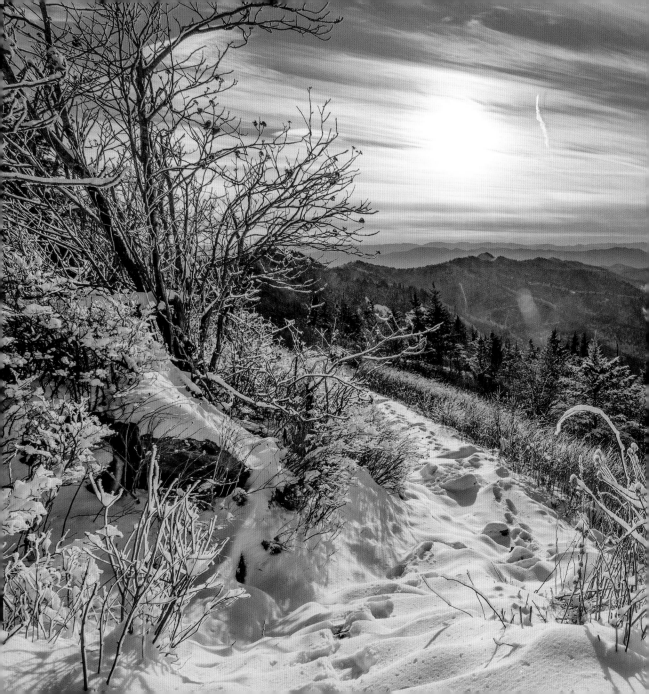

SHENANDOAH
NATIONAL
PARK

Shenandoah National Park

WHEN VISITING A NATIONAL PARK FOR THE FIRST TIME, I look for grand vistas, research what features make a region special, and search for others that might be rather unique. In Shenandoah National Park, I found it all. I hiked to wonderful vistas on mountaintops and to beautiful waterfalls in valleys. I saw a lot of wildlife and came upon a diverse variety of wildflowers and plants in the forests along the roadsides, trails, and overlooks. I was surprised to learn about and visit the basalt columns in the park and explore the fractured piles of granite on Old Rag Mountain, which include a number of huge, balanced boulders that appear to defy gravity.

The park is as beautiful and serene as the sound of its name. The 105-mile-long Skyline Drive traverses the length of the park. It has beautiful views from the numerous over-looks and offers easy access to most of the backcountry locations within the long, narrow national park. With 60 peaks higher than 3,000 feet in elevation, and nine waterfall trails to explore, there are many opportunities to enjoy the Shenandoah Mountains.

The magic is in being there, relaxing at the base of a rushing waterfall or strolling along a trail in Big Meadow, watching for wildlife and enjoying the wildflowers. Sunsets in some locations highlight ridge after ridge of mountains, where in others they show off the broad valley on either side of the mountains. When lights come on in the valleys, you realize how separate you are from the rest of the world, and how peaceful and inspirational it can be on a remote summit in the Shenandoah.

(Pages 128–129) Stony Man Mountain at MP 41.7 on Skyline Drive offers wonderful sunset views over the mountain ridges and Page Valley.

▶ *Old Rag Mountain in the eastern Shenandoahs has its share of fun rock scrambles and climbs, with superb views of the Shenandoah Mountains to the west and farmlands to the east.*

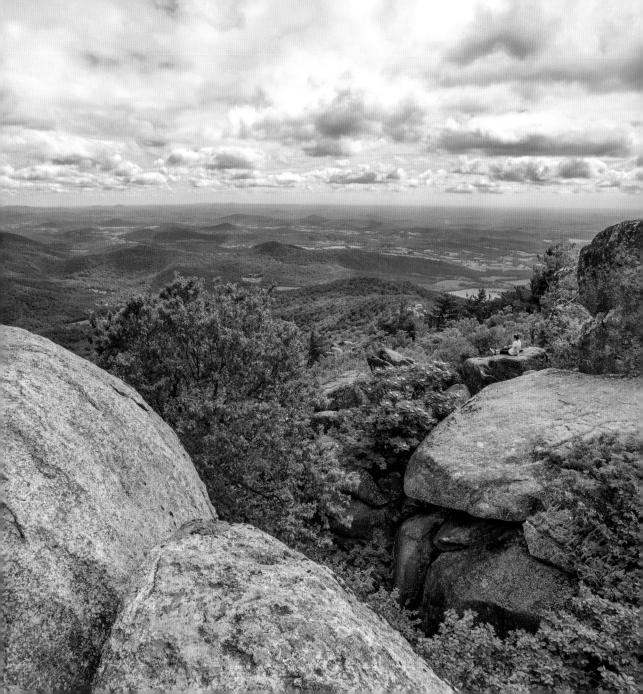

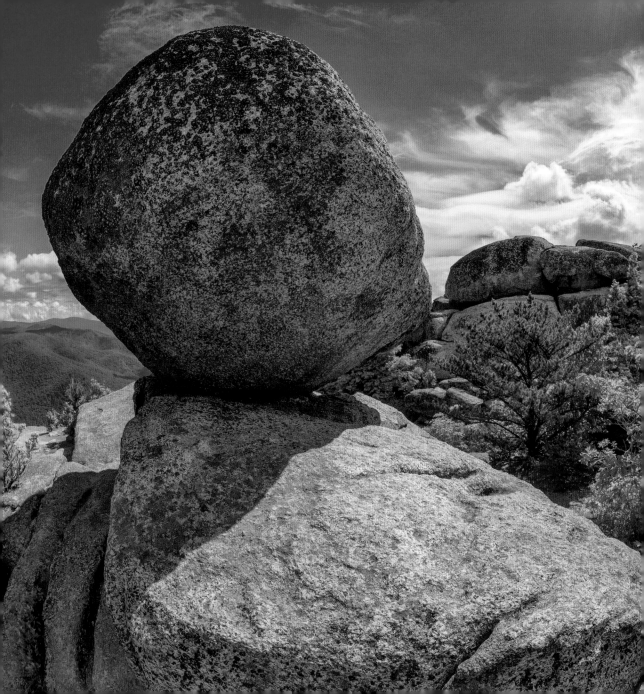

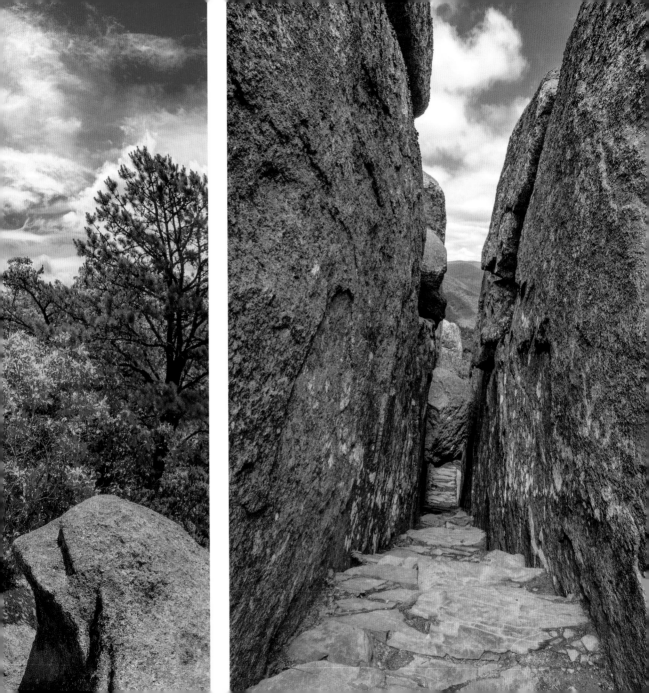

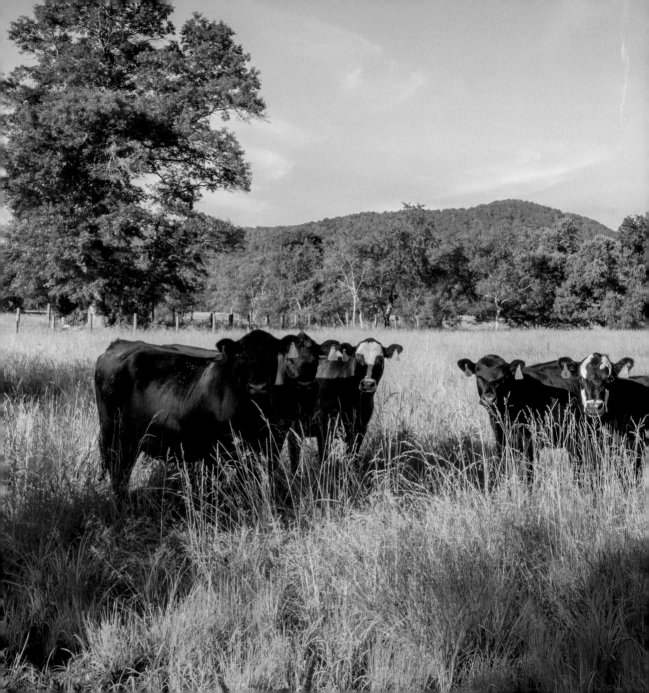

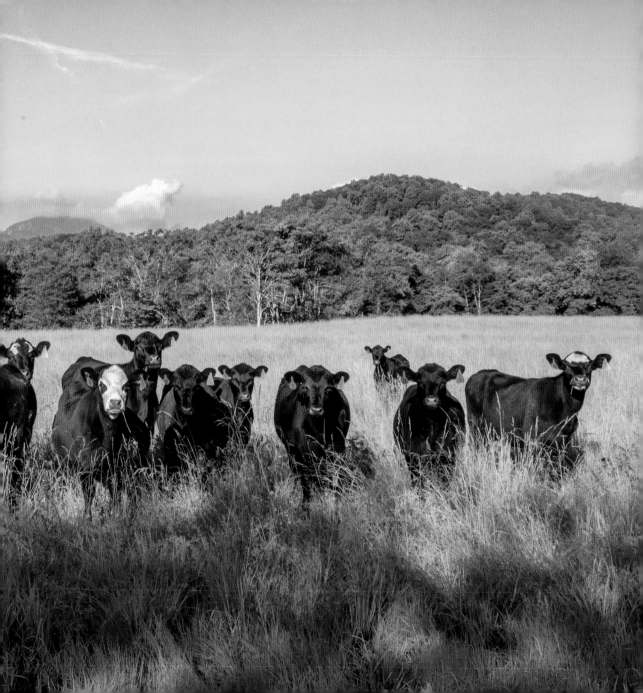

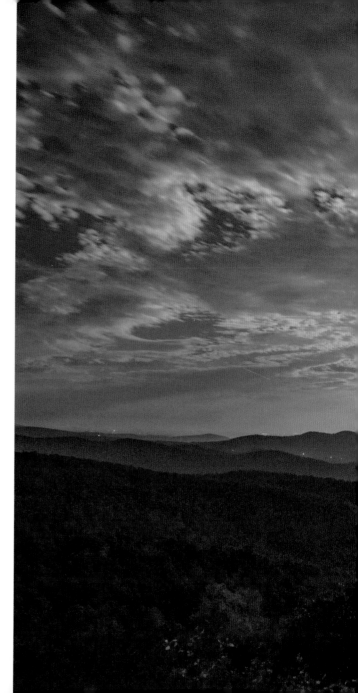

(Pages 132–133) Since there have been no glaciers this far south, it's hard to imagine what forces of nature allowed this Old Rag Mountain boulder to remain, balanced on the granite dome underneath it (left); the rugged trail up Old Rag Mountain requires ducking as well as climbing (right).

(Pages 134–135) These cattle came over to pose in this view toward Old Rag Mountain.

▶ *From the Indian Run Overlook at MP 10.5, the full moon is visible peeking from behind the clouds.*

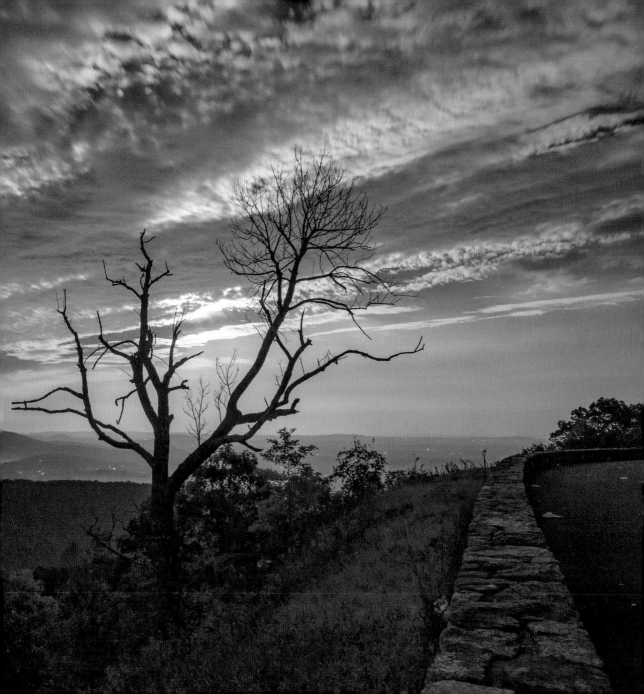

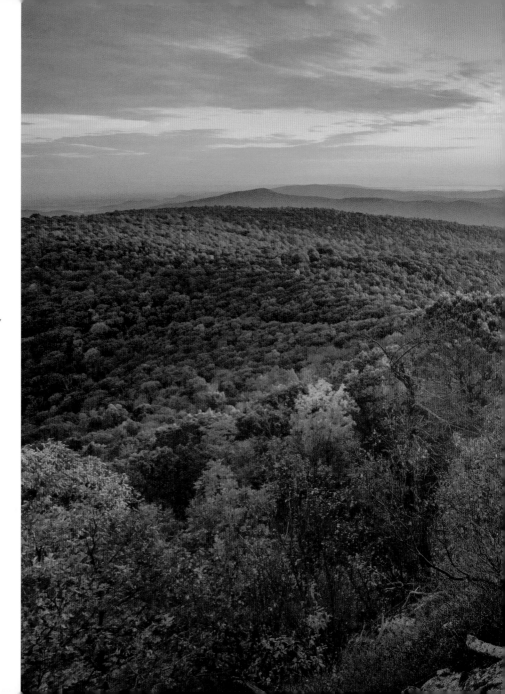

The sun rises over the northern Shenandoah, as viewed from ledges on the north side of Compton Peak.

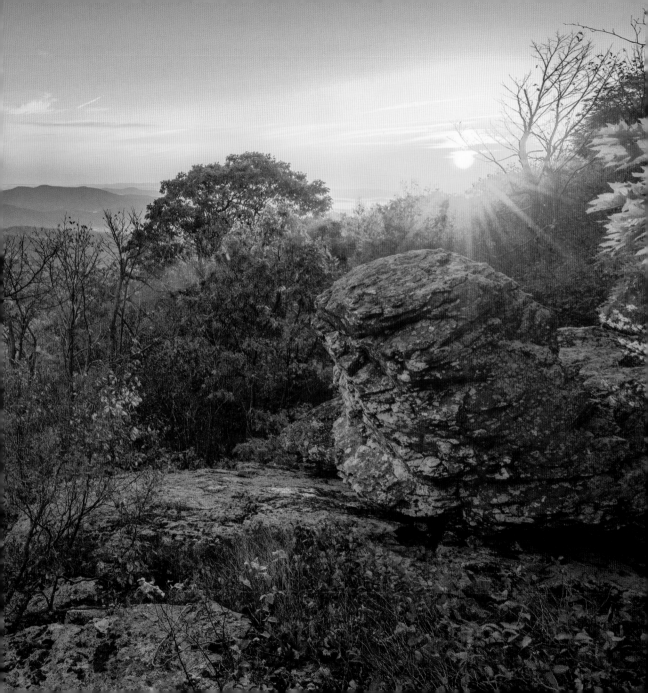

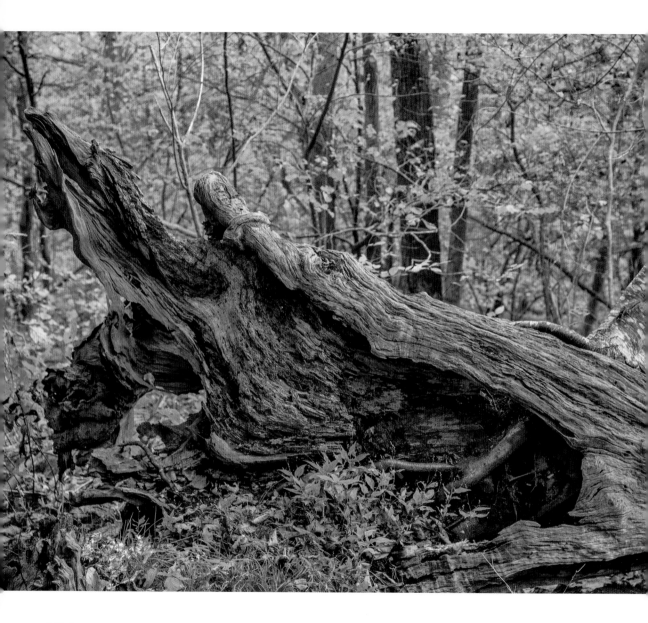

◀ *A giant, weathered fallen oak lies along the Appalachian Trail on Compton Peak.*

▶ *These exposed basalt columns on a shoulder of Compton Peak show the ancient igneous history of the Blue Ridge mountain range.*

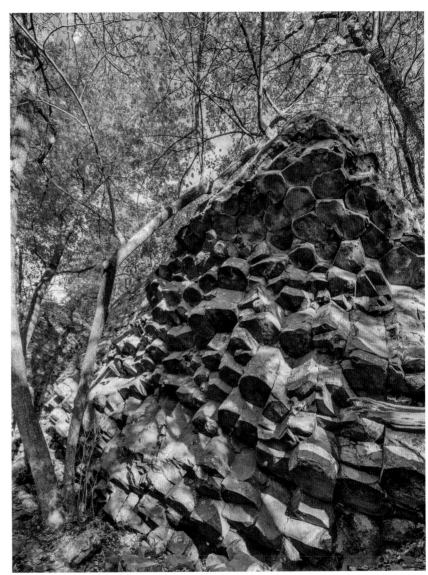

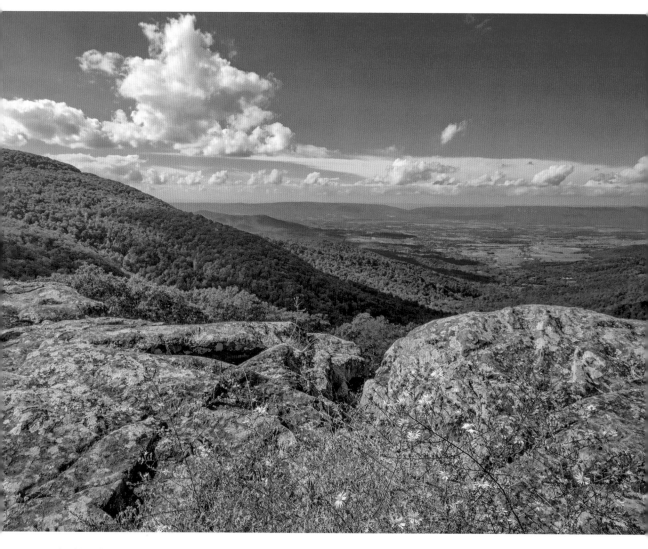

A shoulder of Hawksbill Mountain and the Page Valley farmlands are visible from the Crescent Rock Overlook at MP 44 along Skyline Drive.

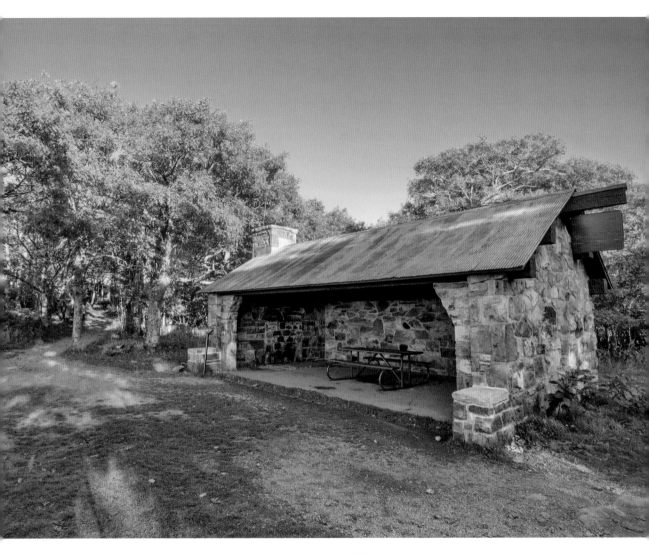

The Byrds Nest No. 2 shelter sits near the summit of 4,050-foot-high Hawksbill Mountain.

▲ A turn on Skyline Drive is seen through the colorful foliage at the Jewell Hollow Overlook at MP 36.5.

▶ Autumn color peaks on an October afternoon along the Appalachian Trail.

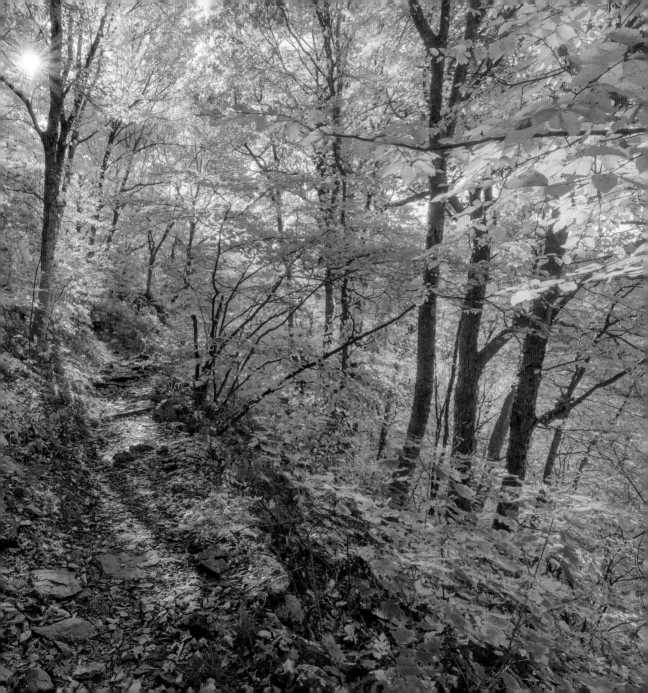

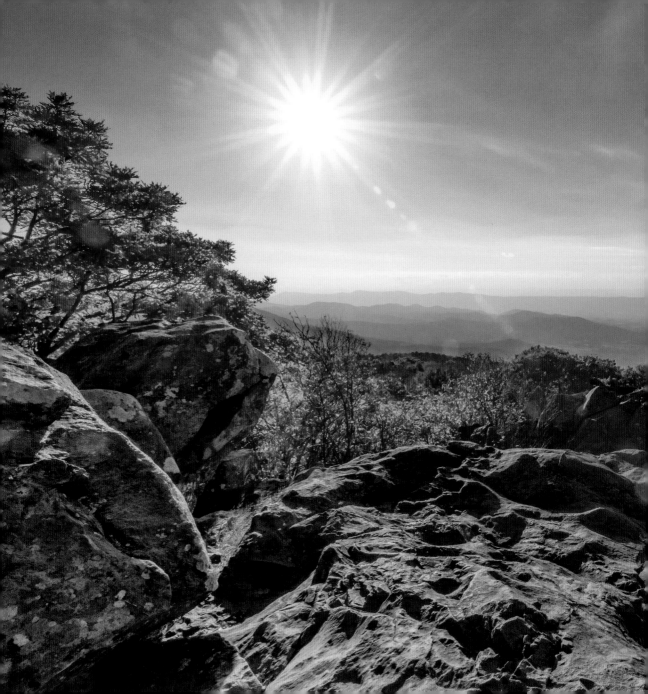

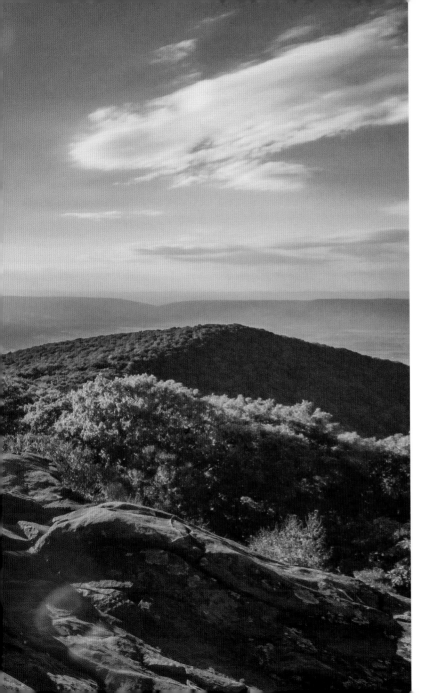

◀ *The late afternoon sun shines on Hawksbill Mountain, the highest mountain in Shenandoah National Park.*

(Pages 148–149) Fall color brightens the Sawmill Ridge Overlook at MP 95.5 (left); morning light shines over the Shenandoah Mountains from Loft Mountain (right).

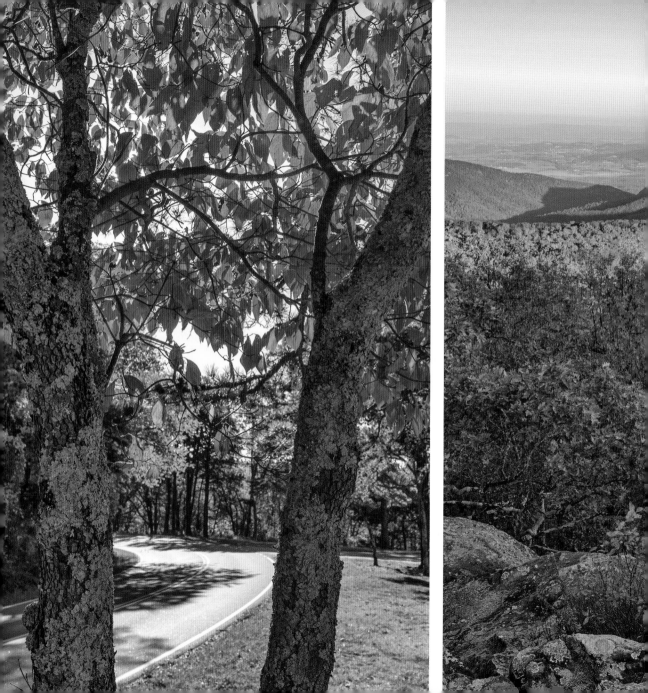

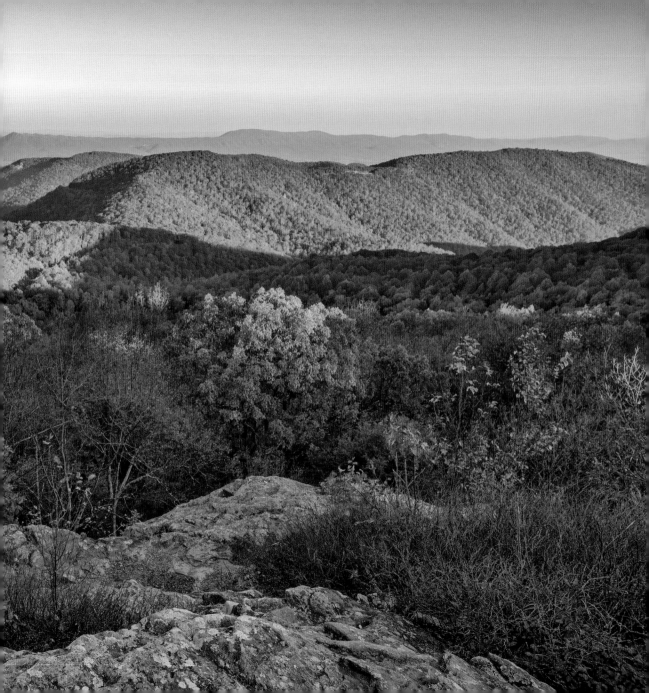

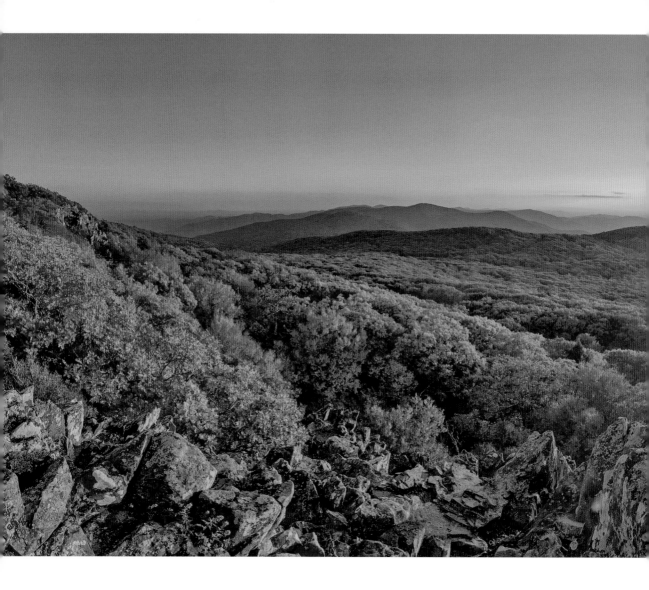

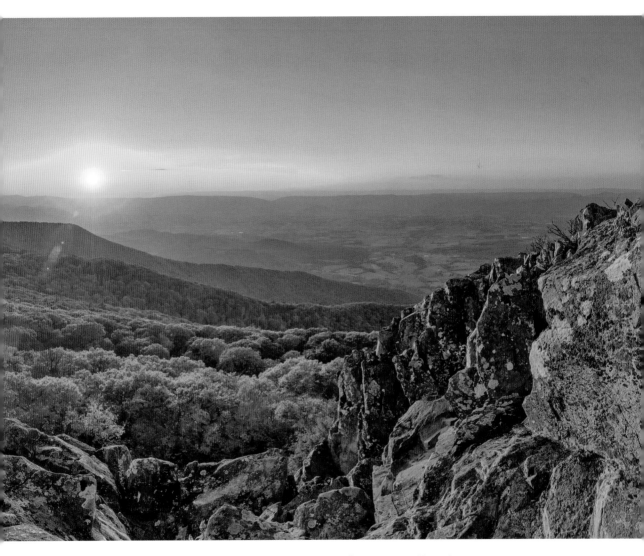

The sun sets over Hawksbill Mountain and the central Shenandoah region from Stony Man Mountain.

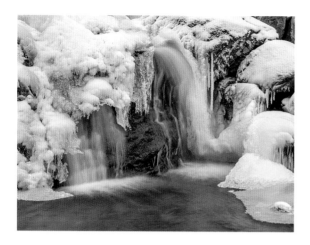

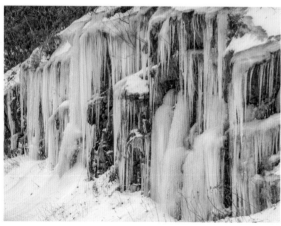

▲ CLOCKWISE FROM TOP LEFT: *The base of Dark Hollow Falls freezes after several nights in the single digits; ice sparkles in the stream below Dark Hollow Falls; icicles form near the Baldface Mountain Overlook; rock ledges along Skyline Drive turn into icy sculptures in the winter.*

▶ *Two mature whitetail deer walk at the edge of Big Meadows.*

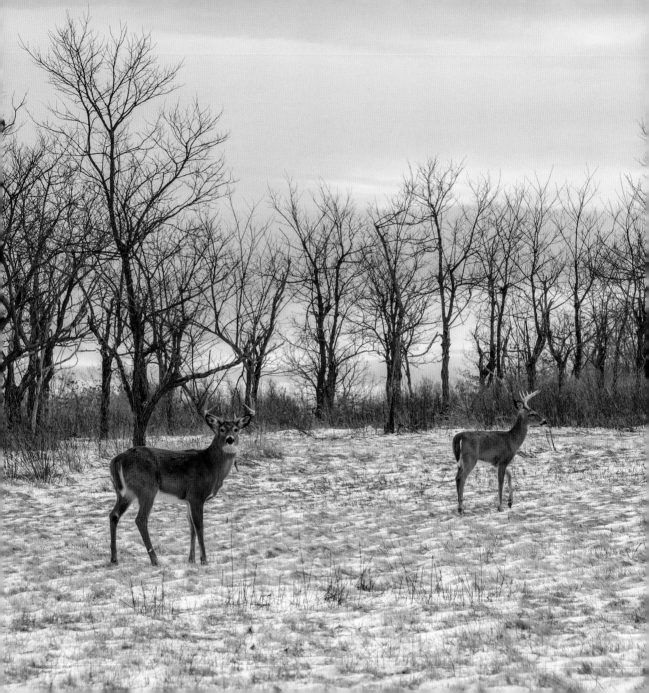

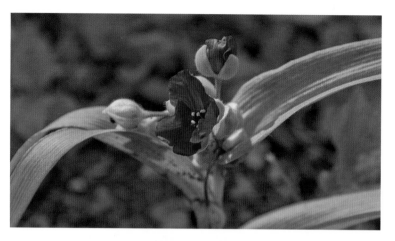

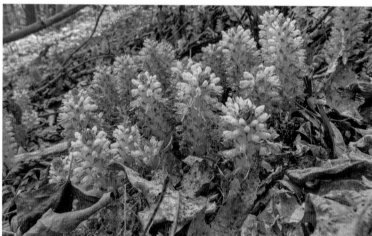

▲ ▲ *Richly colored spiderwort blooms in early May.*

▲ *Bear corn, also known as squawroot or cancer-root, is found all along the Blue Ridge in early spring.*

▶ *South Fork Falls splits into two streams as it cascades 83 feet into the pool at the bottom.*

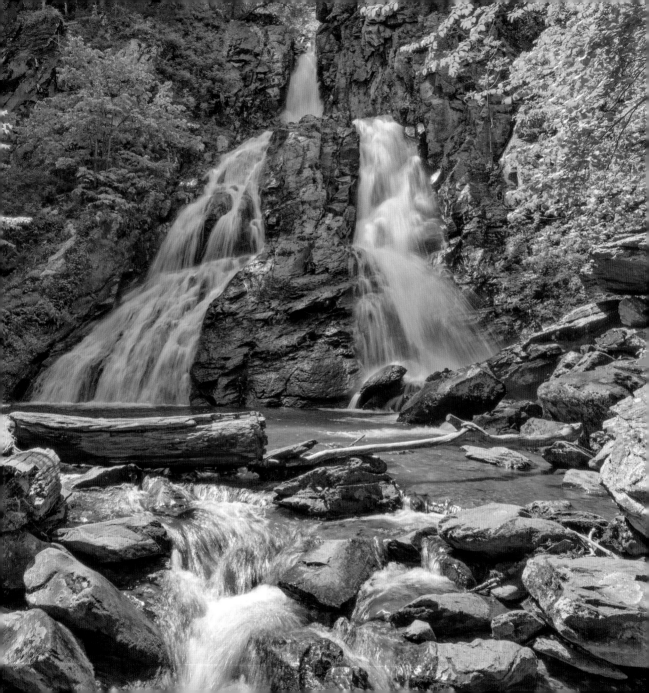

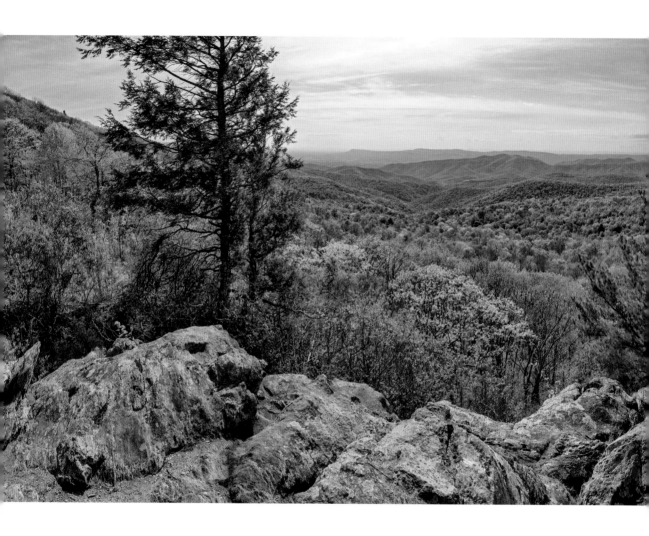

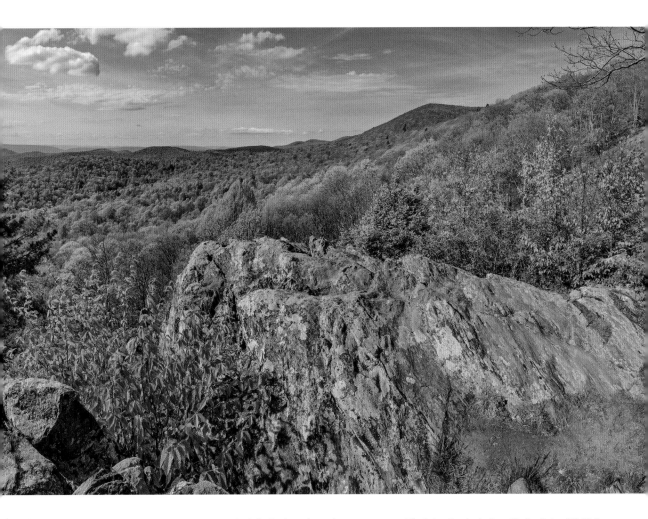

In early May the velvety green of spring covers the hillsides from the rocky promontory at The Point Overlook along Skyline Drive, MP 55.5.

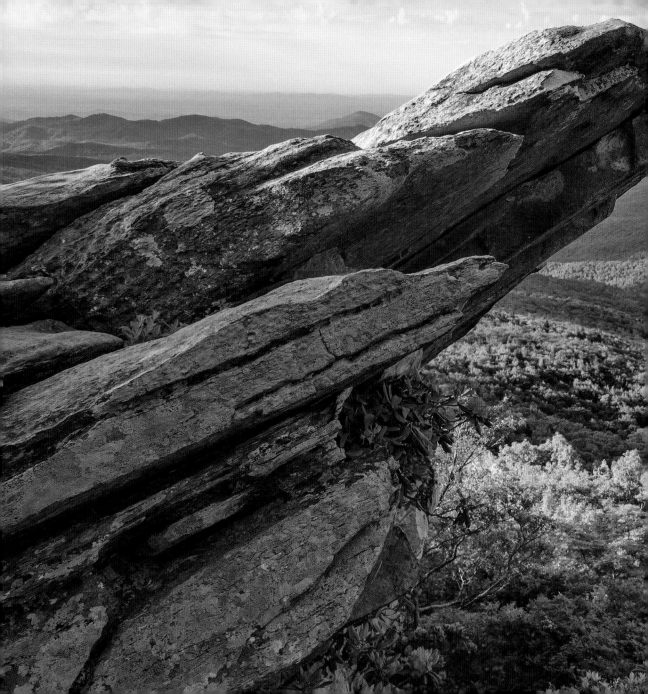

BLUE RIDGE
REGION

Blue Ridge Region

THE MANY DIFFERENT ATTRACTIONS along the length of the Blue Ridge Mountains include natural features and historical sites, state and national parks and monuments, Civil War battlefields, historic homes and estates, festivals, and Native American sites.

The unique geologic history of the Blue Ridge was instrumental in the creation of hundreds of limestone caves. The best known of these—the spectacular Luray Caverns in Luray, Virginia—is a national landmark that offers world-famous cave features in addition to the one-of-a-kind Great Stalacpipe Organ. Not far from Luray is a state park containing a stunning limestone feature, the Natural Bridge. It was once owned by Thomas Jefferson, who thought it was "the most sublime of nature's works."

Grandfather Mountain is perhaps best known for its mile-high swinging suspension bridge, rugged trails along the summit ridge, wildlife habitats, and museum. But it's also much more than a state park, having been recognized as an international biosphere reserve since 1992 because of its unique and rare plant life and treasure trove of ecological diversity.

In Asheville, North Carolina, George and Edith Vanderbilt built their magnificent dream home in the late 1800s against the beautiful backdrop of the southern Blue Ridge Mountains. Their design for the Biltmore, the largest private home in America, was inspired by French Renaissance châteaus and 16th-century castles. The result is a one-of-a-kind American castle that is surrounded by historic gardens, creating another wonderful Blue Ridge landscape to visit and explore.

(Pages 158–159) Rhododendron bloom in June among the craggy rocks along the Rough Ridge section of the Tanawha Trail.

▶ *The Biltmore House is visible from a corner of the Shrub Garden, which contains more than 500 different varieties of shrubs and trees.*

160

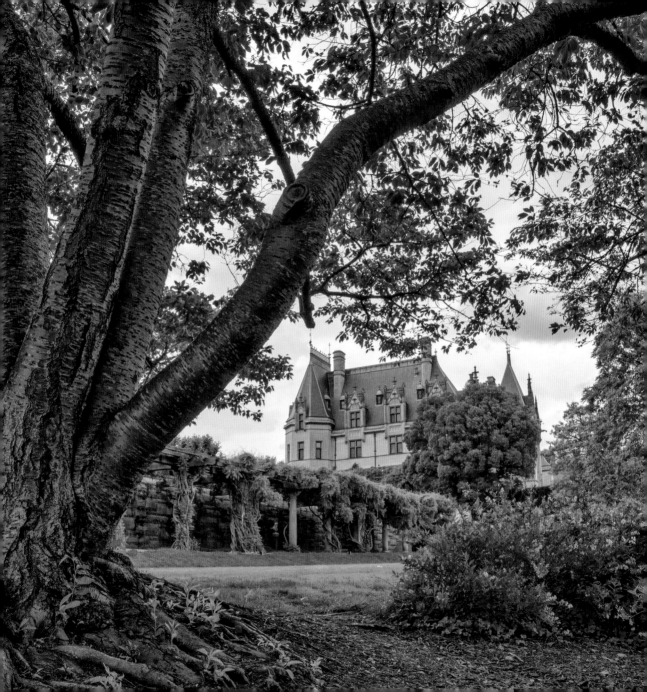

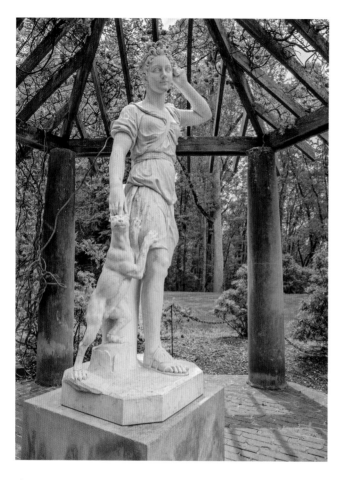

▲ The statue of Diana, goddess of the hunt, sits high on a hill above the Biltmore.

▶ This grand view of the Biltmore House and Blue Ridge Mountains is from the peaceful waters in the Italian Garden.

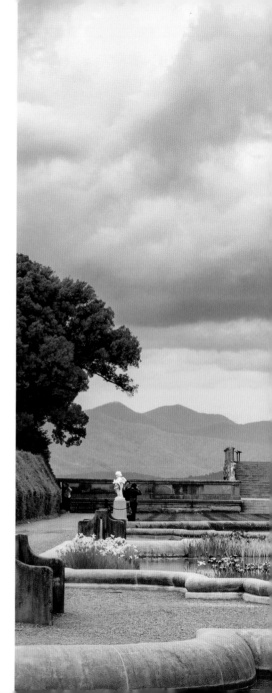

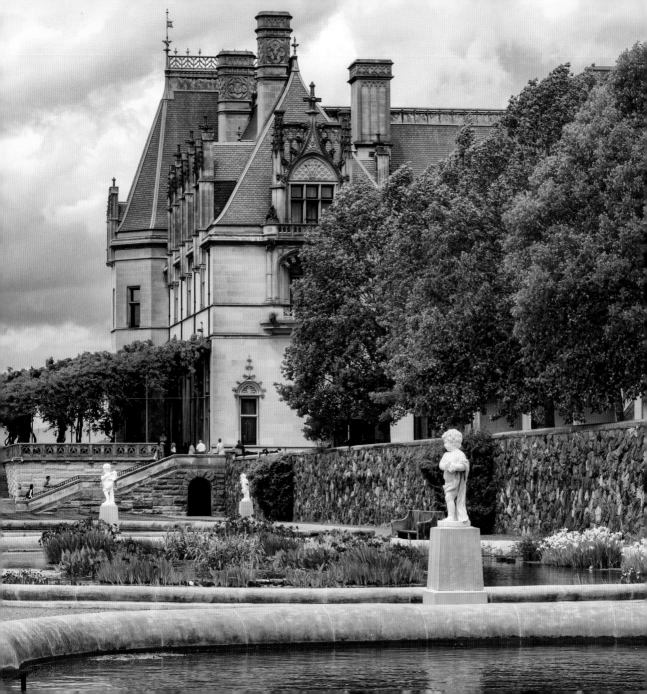

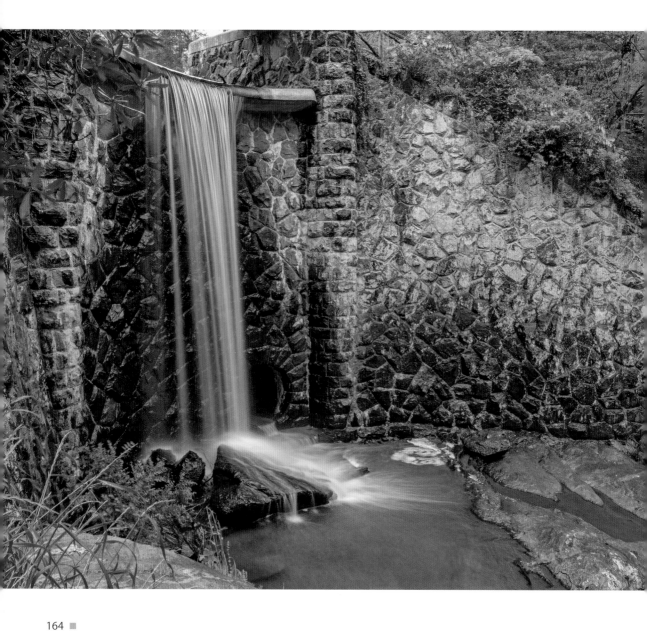

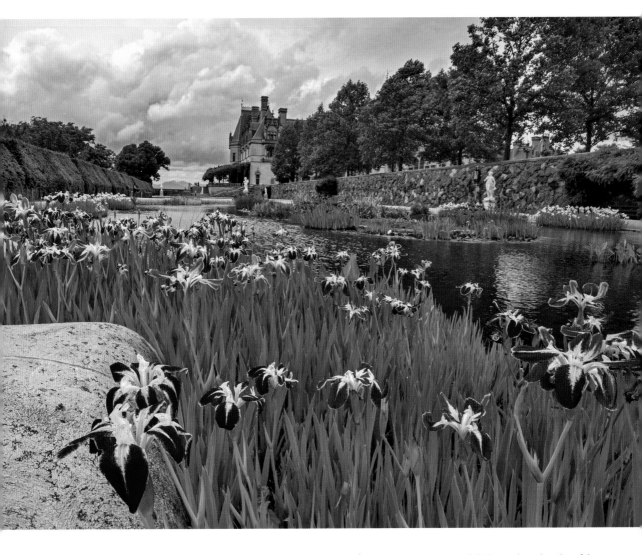

◀ A short distance from the Biltmore House, the stone dam at the outlet of Bass Pond creates a beautiful waterfall.

▲ In early May, irises are in full bloom along the edge of the pools in the Italian Garden.

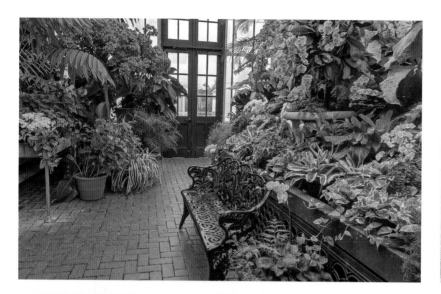

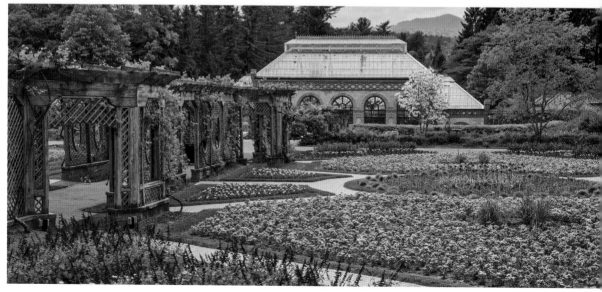

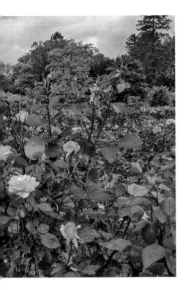

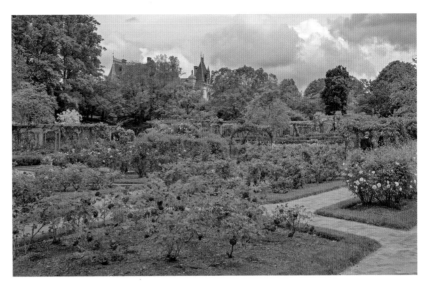

The glass-roofed Conservatory is filled with all kinds of blooming exotic plants (top left); the historic rose garden surrounding the front of the Conservatory building contains heirloom varieties as well as trial species (middle and above); the Walled Garden features a wide variety of seasonal blooms that surround the central grapevine-covered arbor (bottom left and left).

(Pages 168–169) The Blue Ridge Mountains south of Asheville, North Carolina, provide a magnificent backdrop for the Biltmore House from the hilltop by the statue of Diana.

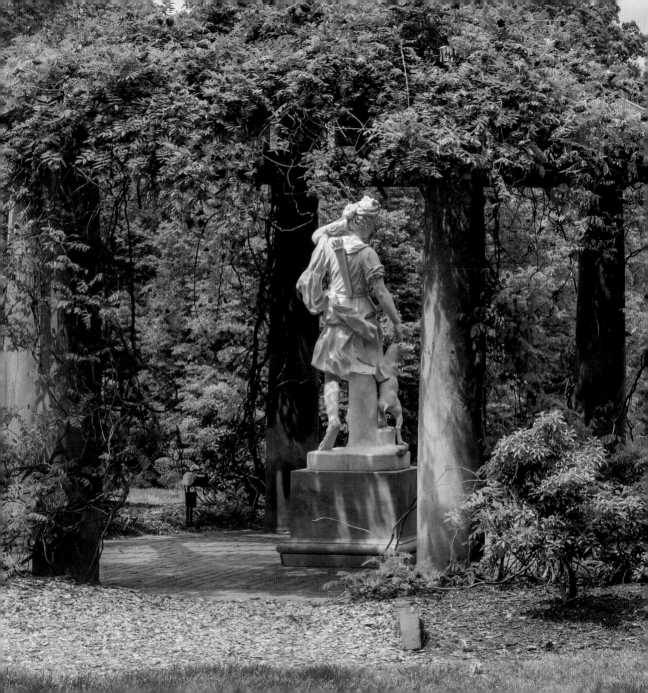

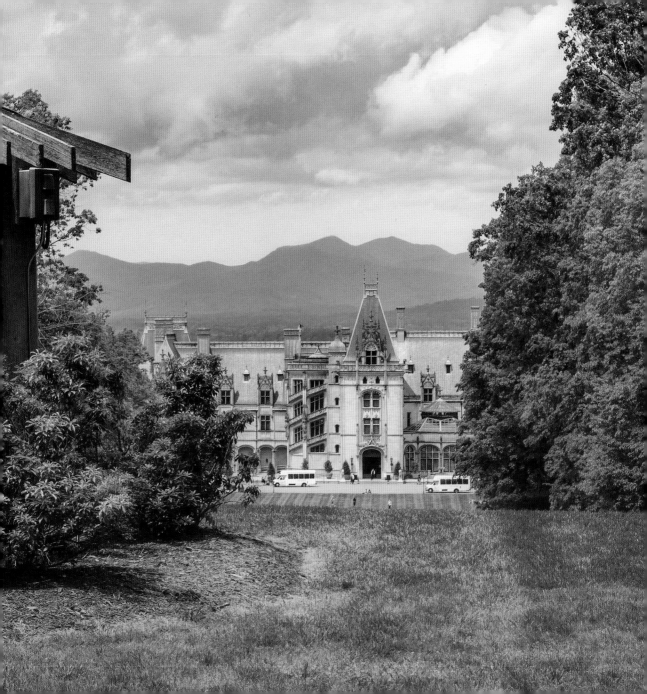

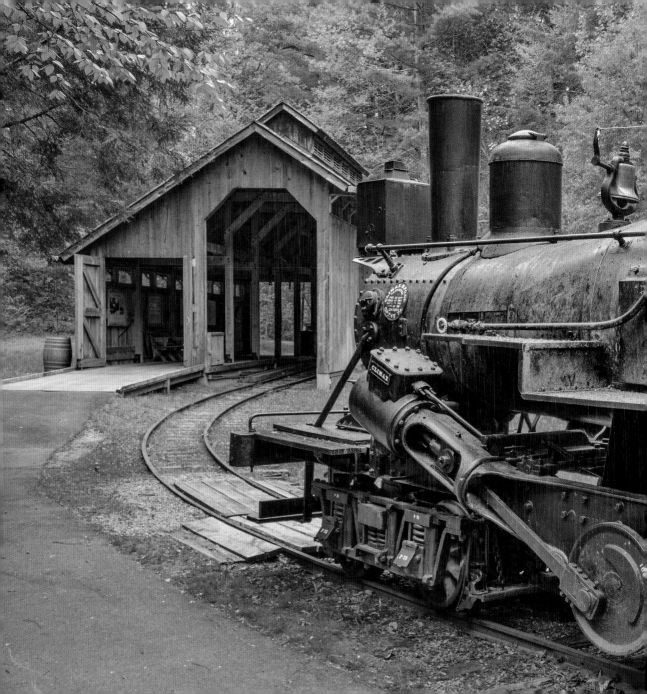

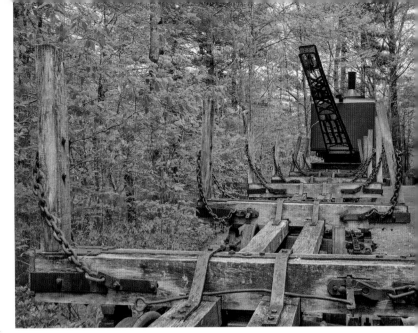

The Cradle of Forestry in America, just a few minutes from the Blue Ridge Parkway, is the legacy of George and Edith Vanderbilt of the nearby Biltmore Estate. In addition to the logging exhibit (left and top right), there is a steam-powered portable sawmill (bottom right), plus many other exhibits, films, and the Biltmore campus, America's first forestry school.

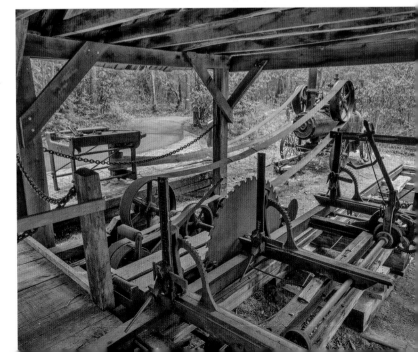

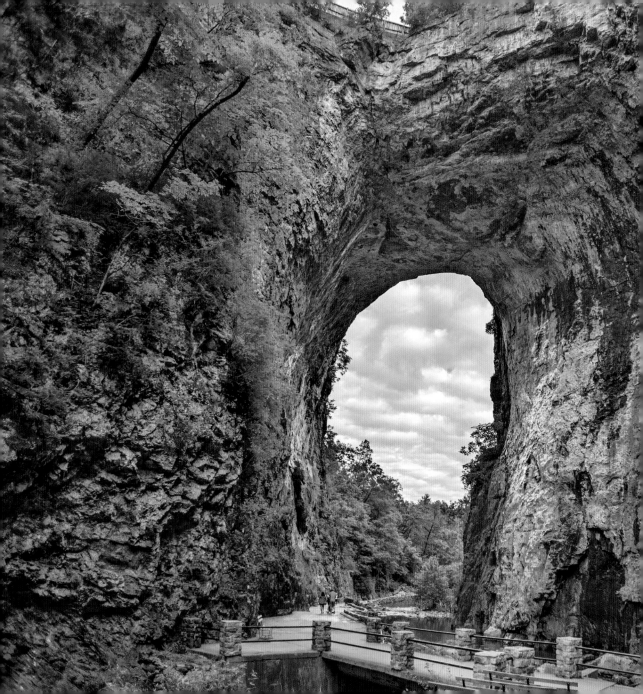

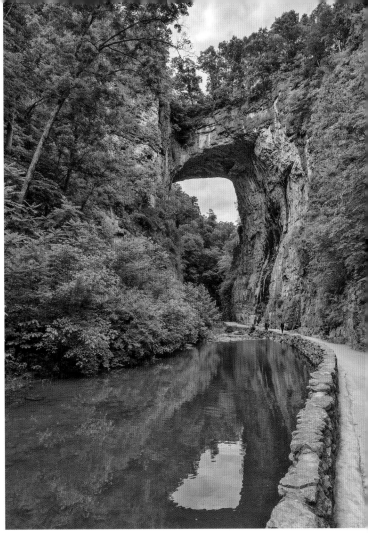

The monumental Natural Bridge on the west side of the Blue Ridge is a Virginia state park with a 215-foot-high natural limestone arch that spans 90 feet wide. This arch actually is a bridge, as it supports US Route 11 overhead.

Internationally renowned artist Ben Long painted this fresco, The Last Supper, *in the beautiful Holy Trinity Episcopal Church of Glendale Springs, North Carolina.*

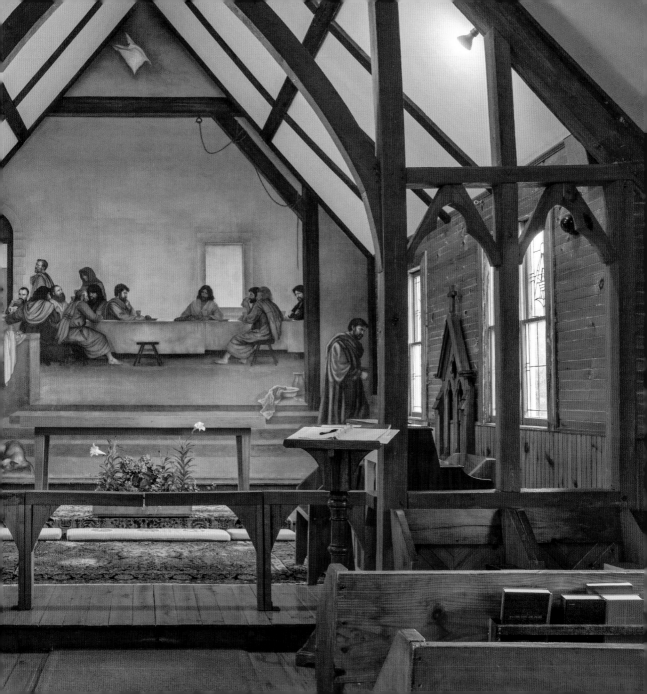

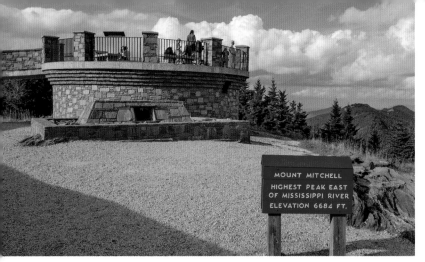

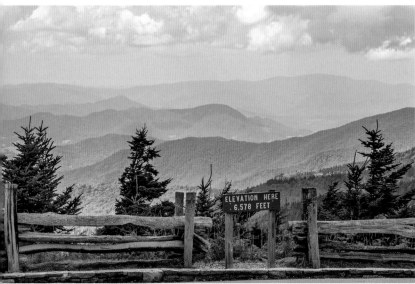

At 6,684 feet above sea level, Mount Mitchell is the highest mountain in the eastern United States. The summit, covered in both balsam and spruce, has great views over the Blue Ridge Mountains from the observation tower (top), the walkway to the tower (right), and the parking lot at the summit (above).

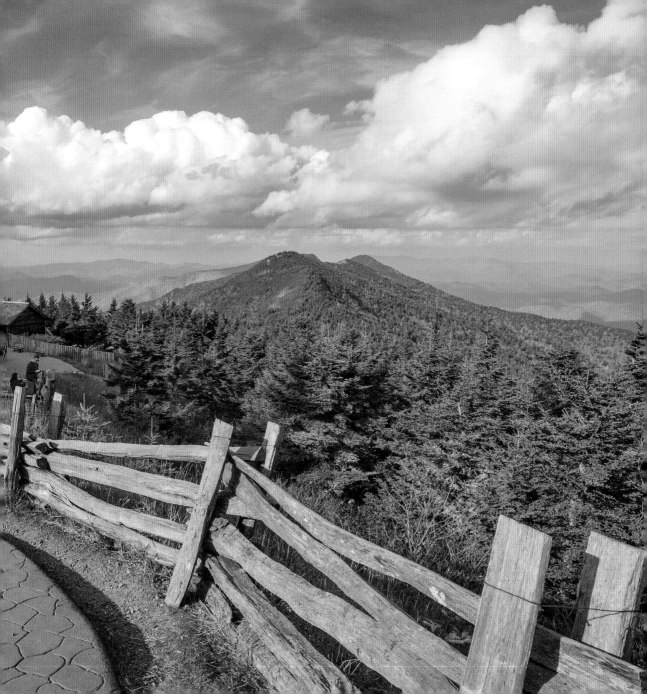

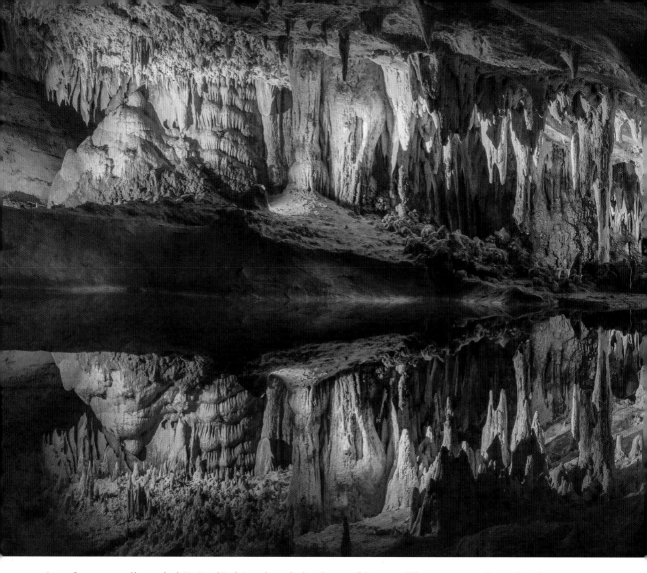

Luray Caverns, near Shenandoah National Park, is perhaps the best known of the many different caverns and caves found along the Blue Ridge Mountains. Dream Lake offers a perfect reflection of the multitude of colorful stalactites and stalagmites around the shallow pool.

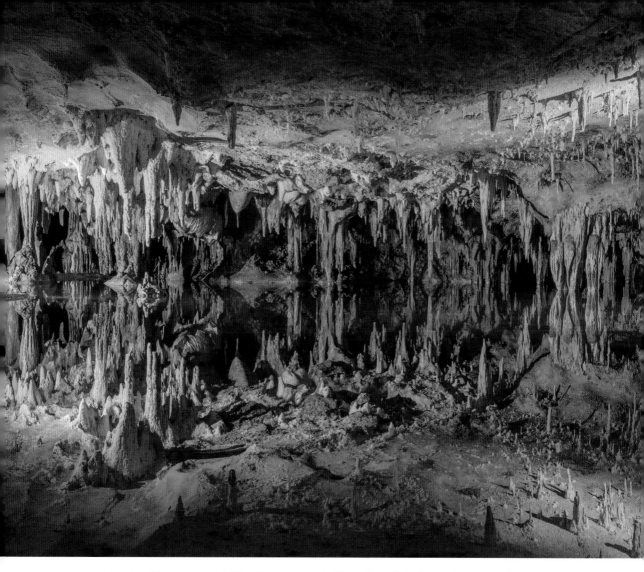

(Pages 180–181) A variety of formations are visible at the entrance to the Throne Room (left); there are "totem pole" formations near the huge fallen stalactite (middle); Luray Caverns' Great Stalacpipe Organ taps specially tuned stalactites to play an otherworldly song that gently echoes through the huge cavern (right).

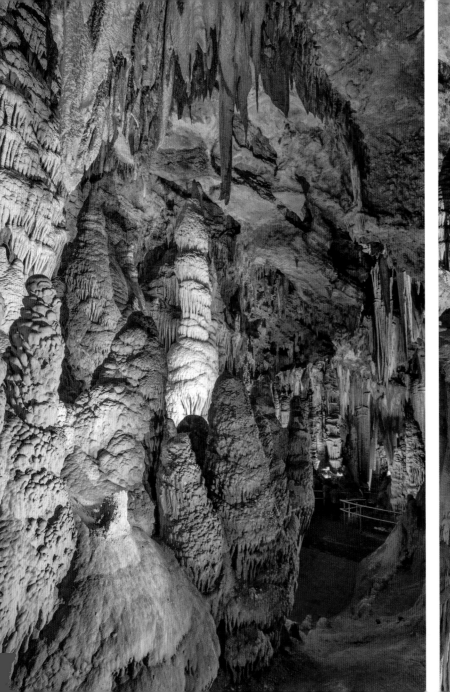
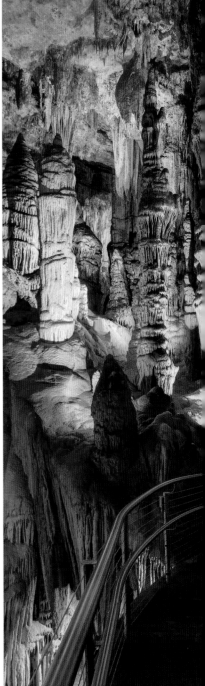

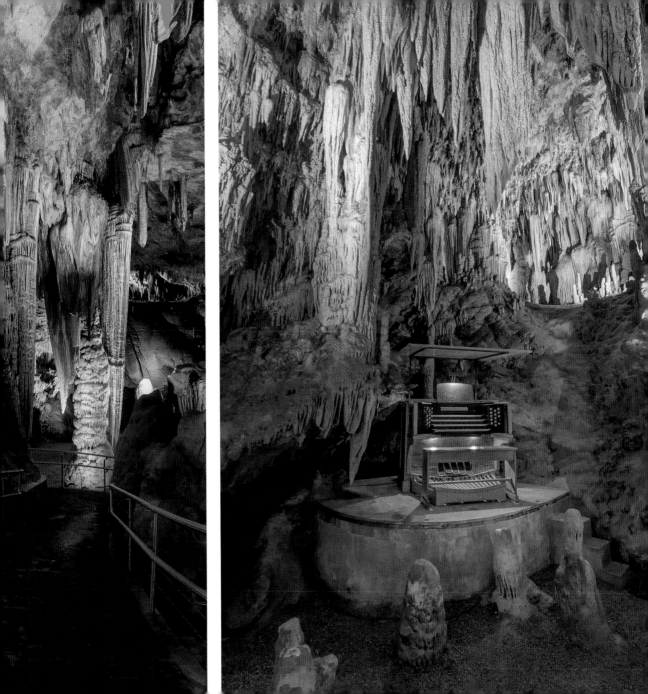

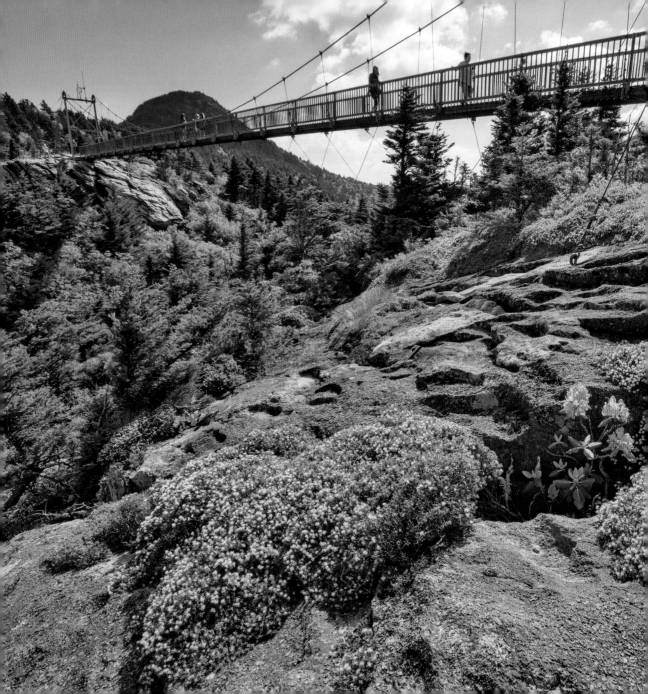

◀ The mile-high swinging bridge on Grandfather Mountain offers fabulous views over the Blue Ridge region.

▶ A "cinnamon" bear shakes water off as it emerges from a pool in the wildlife habitat.

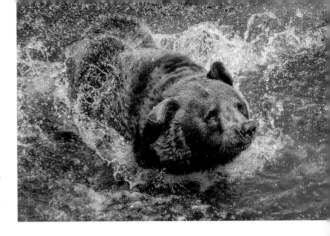

▶ Bottle gentians bloom along a Grandfather Mountain State Park trail.

▶ The bald eagle, seen here in a Grandfather Mountain wildlife habitat, is the only eagle that is unique to North America.

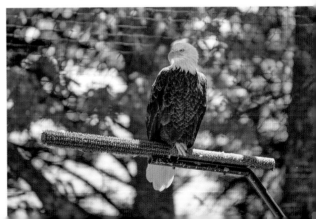

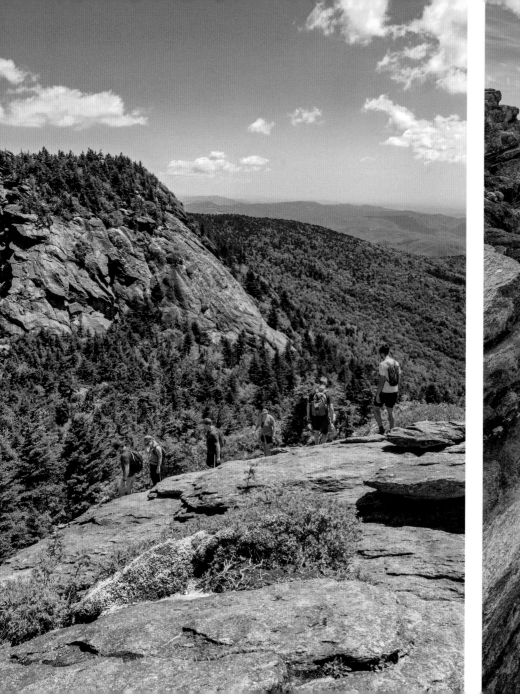
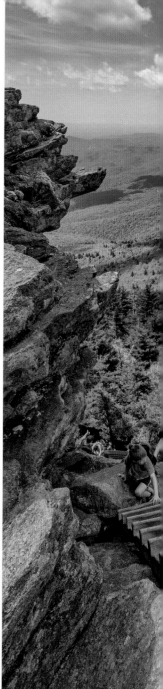

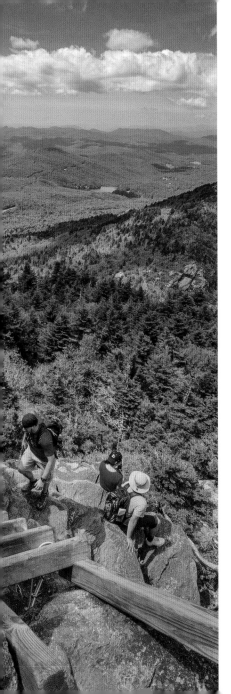

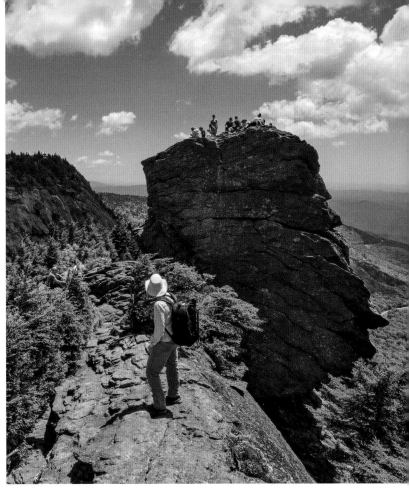

The rugged trail up MacRae Peak in Grandfather Mountain State Park climbs up jagged cliffs by way of wooden ladders and anchored cables to reach what feels like the top of the world, with views in all directions over the parkway and the Blue Ridge Mountains.

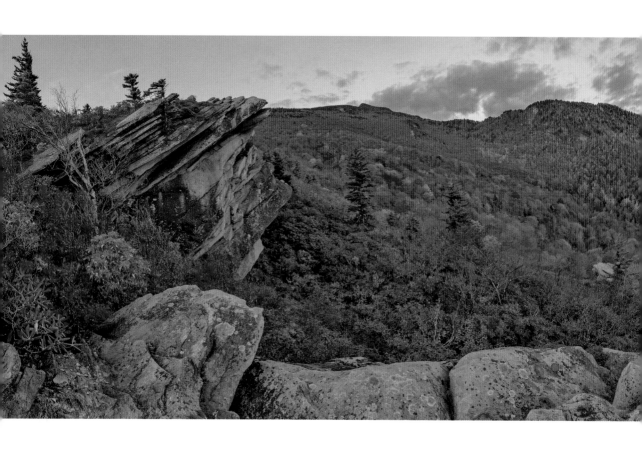

Early morning light shines on the ridgeline of Calloway Peak in Grandfather Mountain State Park, as viewed from the Top Crag area of the Cragway Trail.

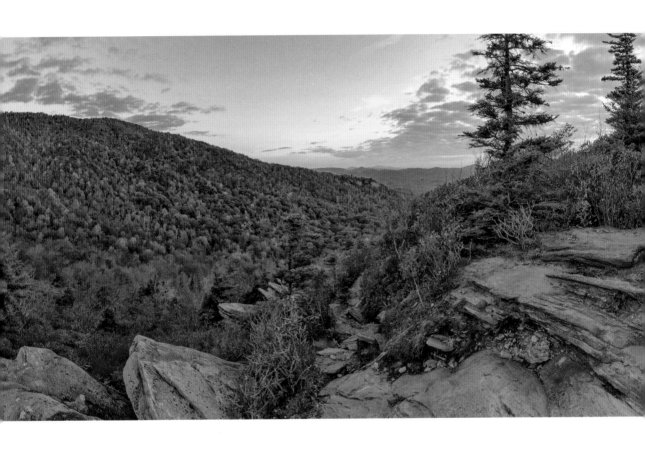

(Pages 188–189) *Fall colors brighten the view toward the Blowing Rock area from along the Cragway Trail in Grandfather Mountain State Park (left); leaves fall onto the Boone Fork along the Tanawha Trail at the edge of the state park (right).*

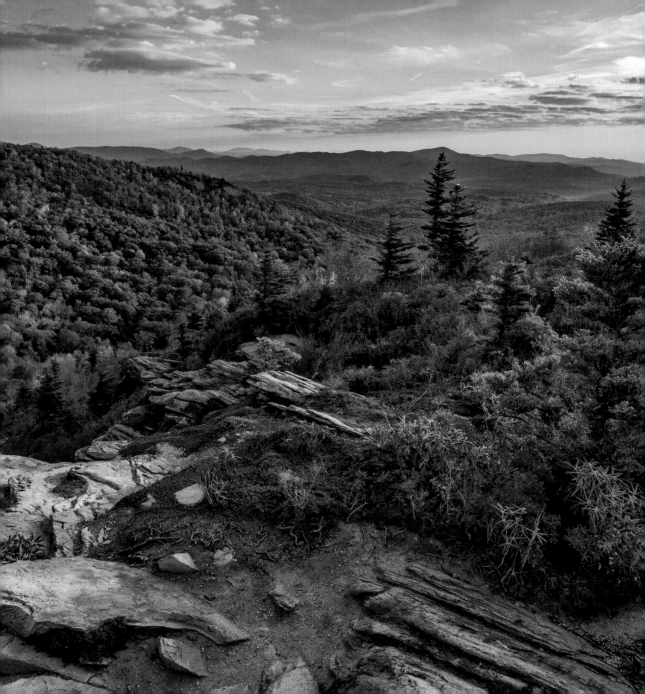

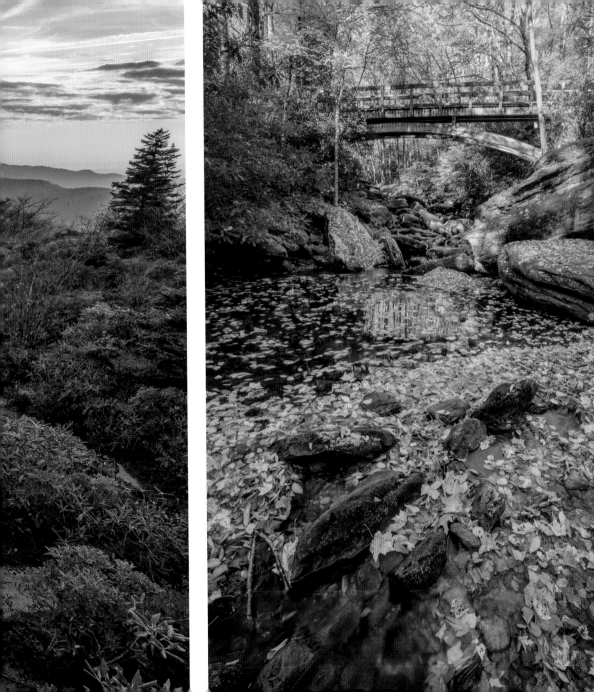

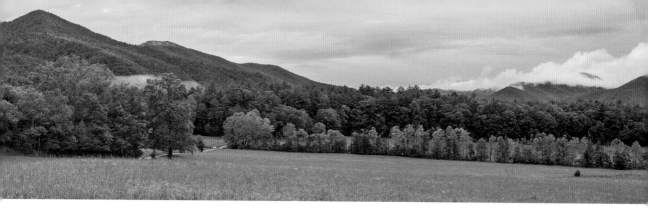

Acknowledgments

FIRST AND FOREMOST, A HUGE THANK-YOU to my wife, who in her own special way supported me fully on this yearlong photography sojourn. She held the fort while I was away, and did all she could to keep things going while I was immersed in the many details of getting a new book together. Many thanks also to my daughter Greta, who takes care of my office work while I'm gone, and who is our primary person for all the high-res color work for the photography in this book. And thanks also to my son Carl, who first traveled in the Smokies with me some years ago, and my sister, Mary Alice, who also was along on a Blue Ridge trip many years ago. She supported the project in various ways, including a place to stay on the way back home!

Thanks so much once again to Rizzoli for offering me this book and taking care of the publishing details. I have especially enjoyed working with associate publisher James Muschett, book designer Lori S. Malkin, and editor Candice Fehrman, as well as publisher Charles Miers. I appreciate their attention to detail and keeping things on track, as well as the terrific quality of the final product. A huge thanks also to Laurel Rematore and the Great Smoky Mountains Association for their support of this project. Many thanks also to Caitlin Worth of the Blue Ridge Parkway for her time in checking everything and offering suggestions.

▲ *From a beautiful overlook at the northwest corner of the Cades Cove Loop Road, soft light filters in over the mountains after sunset.*

(Page 192) Morning mist rises by the old smokehouse at the Dan Lawson Place on the south side of the Cades Cove Loop Road.

190 ■

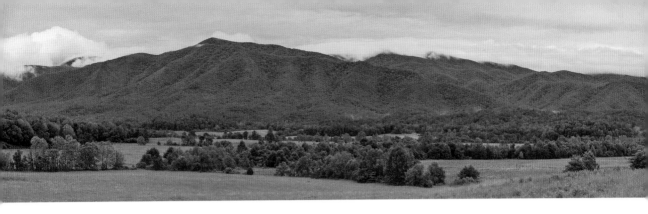

In addition, I have appreciated help on the project from a number of people, including personnel at the Biltmore Estate, the National Park Service, and the Cradle of Forestry; Susan McBean at Grandfather Mountain State Park; Frank Ruggiero at the Grandfather Mountain Stewardship Foundation; Robert McGraw at Mount Mitchell State Park; Bill Huffman and guide Tara Jewell at Luray Caverns; the folks at Natural Bridge; and Ben Long, Barbara Sears, and Becky Gillum. And there were many others I met and enjoyed the company of on different trips, including Steve and Linda Berry, Scott Seagle, Ruth Wellborn of Ely's Mill, Ned Leary, Chad Jones, Jason Frye, Jean-Pierre Plé, Kimberly Diane Davis, Kira Marchant, Eric Albright, Ryan Lubbers, Carrie and Robert Fehr, MD, Caden and Jerika Scott, and many others whose names I did not get.

Thanks also to the authors, editors, and publishers of the National Geographic and National Park Service maps and the following books: *Hiking and Traveling the Blue Ridge Parkway*, *Great Smoky Mountains National Park: Must-Do Hikes for Everyone*, *Shenandoah National Park: Must-Do Hikes for Everyone*, *The Photographer's Guide to the Blue Ridge Parkway*, and *Photographing the Great Smoky Mountains*.

Any project like this one is a joint effort, and I greatly appreciate everyone who has been involved in some way. Thank you!

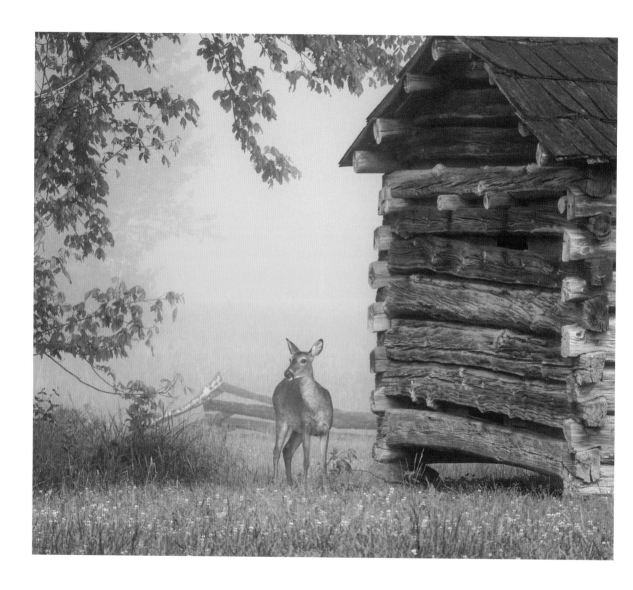